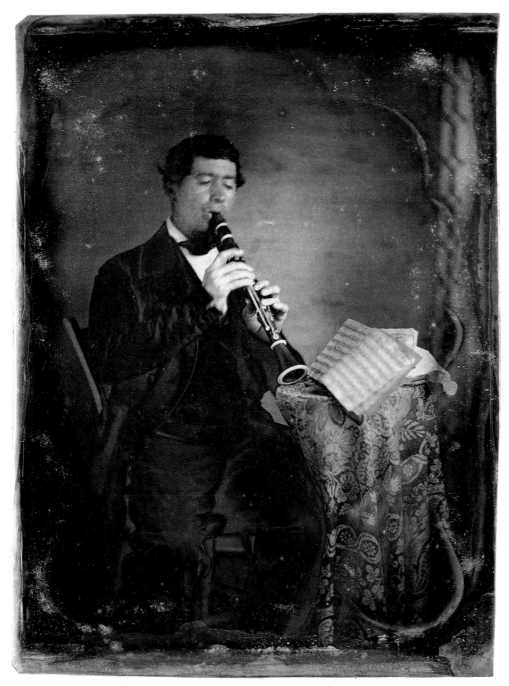

Anonymous, American: *Clarinettist, c.* 1850 (daguerreotype, plate 7·8 × 10·7 cm, quarter plate, Richter Collection)

STEFAN RICHTER

THE ART OF THE DAGUERREOTYPE

with an Introduction by Helmut Gernsheim

VIKING

Once again, to Angela

VIKING

Published by the Penguin Group
27 Wrights Lane, London W8 5TZ, England
Viking Penguin Inc., 40 West 23rd Street, New York, New York 10010, USA
Penguin Books Australia Ltd, Ringwood, Victoria, Australia
Penguin Books Canada Ltd, 2801 John Street, Markham, Ontario, Canada L3R 1B4
Penguin Books (NZ) Ltd, 182–190 Wairau Road, Auckland 10, New Zealand

Penguin Books Ltd, Registered Offices: Harmondsworth, Middlesex, England

First published 1989
10 9 8 7 6 5 4 3 2 1

Photographs on pp. ii, 8, 13 and 21–135 and text copyright © Stefan Richter, 1989
Introduction copyright © Helmut Gernsheim, 1989

Designed by Wilf Dickie

Typeset in Linotype Meridien by Wyvern Typesetting Ltd, Bristol
Printed in Spain by Cayfosa Industria Gráfica
Colour origination by Colorlito Rigogliosi s.r.l. Italy

A CIP catalogue record for this book is available from the British Library

ISBN 0-670-82688-X

By the same author: Tattoo

Contents

Acknowledgements

I cannot easily say how much I owe my wife, Angela, for constant support throughout the project. With her exceptional eye for imagery, she has helped me through the years to build up this collection – and life with a fanatical collector is not always easy! To both our families, for their faith and support, my sincere thanks.

It is not possible to name here all those people, collectors and dealers, who have helped me in my search for outstanding daguerreotypes; to all of them I extend my heartfelt gratitude, and above all to Jonathan, Jean Manuel, Nick, Serge K., Bodo, Howard and Helfried.

Very many thanks to my friend Werner, to whom I owe so much. I am grateful too to the Count, who shared with me his insights and personal experience as a collector of daguerreotypes. It was a constant pleasure to be with them.

I am indebted also to the many experts who helped this project along and supplied much valuable information: Guy Borgé; Brian Coe, Royal Photographic Society; Avril Hart, Victoria and Albert Museum; Dr Brigitte Holl, Heeresgeschichtliches Museum Wien; Mrs Hopkins, National Army Museum; Prof. Dr Jönsson; Dr Kühn, Deutsches Museum; Johann Otto Lingl; Dr Niemeyer, Wehrgeschichtliches Museum Rastatt; Prof. Dr H. Ott; Terence Pepper, National Portrait Gallery; Hans Rilinger and Michael Darchinger; Dr Karl Steinorth, Kodak A G; Naomi Tarrant, Royal Museum of Scotland; Dr Vinturoli, Armeria Reale Torino.

I would like to express my warm gratitude to David Elliott, who was most helpful, and to Marilyn Warnick, without whose enthusiasm this book would never have come into being; also to Fiona Carpenter, Wilf Dickie, Eleo Gordon, Elizabeth Hallett and Helen Jeffrey for their valuable work, and to Chris Miller, who did a marvellous job on the text.

All reproductions were taken with a Hasselblad 500 C/M, Zeiss Planar 2·8/ 80 mm, extension rings, on Kodak Ektachrome E P R, indirect illumination with Multiblitz Variolite studio flash.

Stefan Richter
October 1988

Note to the Reader

Regarding the plate on p. 104 (*Pornographic scene*): the detached second half of this stereograph was stolen from a gallery in Vienna in September 1984. The author and the Vienna police would welcome any information on its whereabouts.

Stefan Richter is always interested in hearing from fellow collectors and may be contacted c/o A.R., 8 Lenhurst Way, Worthing, West Sussex BN13 1JL, England.

Introduction

SINCE THE RENAISSANCE THE camera obscura has served artists as a method of projecting, in correct perspective, an image of nature that could then be traced in a fraction of the time necessary for the equivalent drawing. We know, for example, that it was used by Vermeer and Canaletto, among many others. And as early as 1800 Thomas Wedgwood tried to fix the image it projected.

Wedgwood, son of the famous English potter, was the first to bring optics and chemistry together in an attempt to record the image. The account of their abortive efforts was published by his collaborator, Sir Humphry Davy, in June 1802 in the *Journal of the Royal Institution*. Fourteen years later Nicéphore Niépce, a French landowner, wishing to make lithographs and reconciled to the inadequacy of his own draughtsmanship, attempted to fix the image of the camera obscura on stone; this he succeeded in doing in 1824.

William Henry Fox Talbot, an English landowner and scientist, wanted to secure mementoes of his travels, and the idea of fixing the image occurred to him while he was sketching with the aid of a camera obscura at Bellagio, on Lake Como, in 1833. 'How charming it would be if it were possible to cause these natural images to imprint themselves durably and remain fixed upon the paper,' he wrote, and on his return began experiments with this goal in mind. Daguerre did not record his motives,

but as a naturalist painter he frequently made use of the camera for his sketches, and the time that would be saved by securing its image was no doubt a consideration.

In 1822 Niépce succeeded in producing a photographic copy of an engraving; he first waxed the engraving to render it transparent, then, placing it on a glass plate

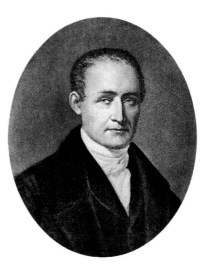

Léonard-François Berger: *Portrait of Joseph Nicéphore Niépce*, 1854 (Société Française de Photographie, Paris)

Joseph Nicéphore Niépce: *View from his window at Le Gras, c.* 1827 (heliograph, Gernsheim Collection, University of Texas, Austin)

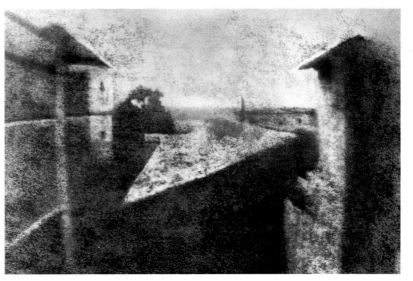

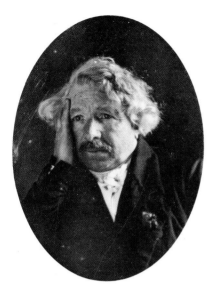

The Meade Brothers: *Portrait of Louis Jacques Mandé Daguerre* (daguerreotype, Division of Photographic History, Smithsonian Institution, Washington)

photosensitive with bitumen, laid it in the sun. Two years later he produced the first heliograph – a sun-drawing on stone – in his camera; it is no longer in existence. It showed a view of the courtyard of his country house, the Maison du Gras, in the village of Saint-Loup de Varennes, a few miles south of Chalon-sur-Saône. The world's first photograph, which I rediscovered and exhibited in 1952, was taken in 1827 on an asphalt-coated pewter plate. The exposure required for this 16·5 × 21·5 cm picture was at least eight hours, and the sun is shining on both sides of the courtyard.

Niépce was an impoverished country gentleman, living on his estate, who sought to better his fortune by various inventions. Two of these were in some degree successful: heliography and a steam-powered boat. A third, *perpetuum mobile*, proved chimerical. The twenty-five years he devoted to these inventions were not

remunerative, and after his death Niépce's widow was forced to sell the estate.

Louis Jacques Mandé Daguerre, by contrast, was the son of a low-ranking clerk. A man of little formal education, he made a brilliant career as a stage designer, academic painter and co-inventor of the Diorama, a spectacle that made use of changing light effects, animation and *trompe-l'œil* techniques to impress the spectator. Daguerre had heard from an indiscreet optician in Paris, who supplied both Niépce and Daguerre with cameras, that Niépce had succeeded in making a picture drawn by light. Daguerre had struggled in vain to do the same, and therefore wrote to Niépce, enclosing a *dessin fumé*, which he claimed to have produced in his camera.

Having failed to get his invention recognized by the Royal Society in London in 1827, Niépce was further discouraged when he read the opinions of the leading lights of French science in the *Journal des savants*: 'Who will ever be interested in the invention of M. N. Niépce? The crushing superiority of Painting is obvious to every eye.' Niépce was not deceived by Daguerre's drawing and found his braggadocio far from congenial, but Daguerre's overtures seemed to offer one last hope for heliography. Despite the clear disparity in the assets of the partners-to-be, they signed an agreement on 14 December 1829. Daguerre declared his willingness to improve the invention and render it more practical, that is to speed up the process.

Niépce died in July 1833, without seeing any improvement in heliography. Then in spring 1835 Daguerre discovered that an exposed plate he had discarded as a failure had acquired an image, as if by magic, after lying overnight in the cupboard in which he kept his chemicals. By removing the chemicals one by one and placing an identical plate in the cupboard as each chemical was

eliminated, he at last realized that a broken thermometer – or rather the fumes of mercury escaping from it – was the mysterious agent of this sorcery. The fumes had acted on the underexposed image. It was not necessary to expose the plate for long enough to create a visible image: thirty minutes' exposure produced a *latent* image, which could then be *developed* into a *visible* one. This discovery was of the utmost importance for the future of photography, and the reduction of the exposure time from eight hours to thirty minutes was no less dramatic an advance. Latent camera images are developed to produce negatives even today, and the process by which prints are exposed under the enlarger and developed into positives has changed relatively little. The physical 'developing' process was different from the chemical one now used: microscopic globules of mercury vapour settled on the areas of silver iodide that had been affected by the light and thus made the image visible.

The next step was to make the image permanent by dissolving the remaining silver iodide. Daguerre, who had no knowledge of chemistry, solved this problem in May 1837, thus succeeding where the famous chemist Sir Humphry Davy had failed. The image was simply immersed in a solution of cooking salt. In 1839 Daguerre adopted hyposulphite of soda, or, more correctly, thiosulphate of soda; this, the best fixing salt, had been publicly advocated by Sir John Herschel, who had discovered its properties in 1819. Daguerre had now departed from Niépce's heliographic method at several points, and he felt entitled to demand that the invention bear his own name. This was clearly an infringement of the contract, but despite his strong protests Isidore Niépce, who had succeeded his father as partner, had to give way in the end.

Daguerre presented his first successful picture, a still life taken in

his studio in 1837, to the director of the Louvre, Alphonse de Cailleux, in the hope that his influence might bring the invention to the notice of artists. This expectation would seem to have been unfulfilled, for Daguerre's next project was the commercialization of the daguerreotype through the sale of at least two hundred licences at a thousand francs each. By driving round Paris, with his voluminous apparatus – it weighed fifty kilograms – mounted on a cart, and very ostentatiously photographing public buildings, Daguerre was assured of considerable publicity without the least expenditure on advertising. But the inhabitants reacted with suspicion: there was too much mumbo-jumbo. Rising fumes from the iodization and images visible only under a cloth were tricks such as they had come to expect from the inventor of the illusionistic Diorama. Not a single licence was sold.

Late in 1838 Daguerre decided to approach a number of distinguished scientists and artists; with their assistance, he hoped, the scepticism of the public could be overcome. This step proved a turning-point in the fortunes of Daguerre and the daguerreotype, for in François Arago, permanent secretary of the Académie des Sciences, he secured a loyal and powerful ally. Arago immediately recognized the importance of the invention to science, art and industry, and, loath to allow it to remain in private hands, put forward the bold idea that the French government should buy it and present it to the world. In this way, he argued, the daguerreotype would be the more quickly perfected and would serve society as a whole. Making energetic use of his position as leader of the Republican opposition in the Chamber of Deputies, Arago, with the support of other scientists, was able to form a powerful lobby, and his campaign gained momentum rapidly. Paul Delaroche, the historical painter, recorded the impact of the invention in

Louis Jacques Mandé Daguerre: *Still life*, 1837 (daguerreotype, Société Française de Photographie, Paris)

his celebrated remark, 'From today painting is dead.'

The speed with which the bill awarding life pensions to Daguerre and Isidore Niépce was pushed through both chambers and received royal approval – the whole process took just under seven months – suggests that the rival claims of Talbot in England were a consideration. On 19 August 1839, at a joint session of the Académie des Sciences and the Académie des Beaux-Arts, François Arago revealed the daguerreotype process. The sensation it created was similar to that caused by the American moon-landing in 1969. Both achievements realized long-cherished dreams of mankind. Arago's presentation of the first practical process is considered the official birthday of photography, and the 150th anniversary of that event will be celebrated in the year of this book's publication.

The French government had grandly

bestowed the daguerreotype as a gift to the whole world, but the gesture was seen as plain hypocrisy when it became known that, five days beforehand, Daguerre had patented his invention in England with Arago's connivance. Arago's motives remain obscure. He may have felt that if the British wanted to take photographs, they could use their own paper-negative process. If it was not as good – and Arago knew that it was not – they would have to acknowledge the superiority of the French method, which they duly and unrestrainedly did. Herschel himself, on a visit to Paris, declared that the images made up to that date in England were 'childish in comparison'. Who but botanists and naturalists would want 'photogenic drawings' of leaves or feathers?

Arago's statement that with the daguerreotype anyone could, in the space of twenty to thirty minutes, make a picture of a landscape more

accurate than an artist's drawing generated such excitement that, before the end of the year, Daguerre's instruction booklet had been printed in thirty editions and eight languages. Publication of the booklet, along with manufacture of the apparatus itself, had been assigned by Daguerre to Alphonse Giroux, a stationer and dealer in artists' materials and a relative of Madame Daguerre's. But the honour of being the first to publish slipped out of his hands. The printer Giraldon betrayed him by delivering a first printing of 300 copies to his competitors, Susse Frères, who were thus able to publish under their own imprint on 6 September. This printing was, in its turn, pirated by other interested parties, such as the optician and publisher Lerebours and Molténi, a manufacturer of optical apparatus, as Giraldon was able to establish in court on 19 December. The judge, however, dismissed the case, arguing that, following the agreement with the government signed by Daguerre and Isidore Niépce on 14 June, the daguerreotype was in the public domain, and the description was therefore common property.

As production of cameras began to catch up with demand, a new phenomenon was to be observed: three-legged boxes were erected in public places, and alongside them were to be found gentlemen consulting their watches. 'Patience is the Virtue of Asses' was the caustic title of Daumier's caricature of these newfangled artists, and photographers could not help but acknowledge the need for patience, though they may have disputed the further imputation. As Arago had foreseen, the arrival of the invention in the public domain set off a series of improvements in equipment, optics and chemistry as Austrian, American, British and French experimenters strove to bring portraiture within the capacities of the new medium.

Clearly, if the bulk of the equipment and the duration of the exposure were to be reduced, the whole-plate picture

Louis Jacques Mandé Daguerre: *View of the Île de la Cité and Notre Dame taken before the public announcement of his discovery in 1839* (daguerreotype, Gernsheim Collection, University of Texas, Austin)

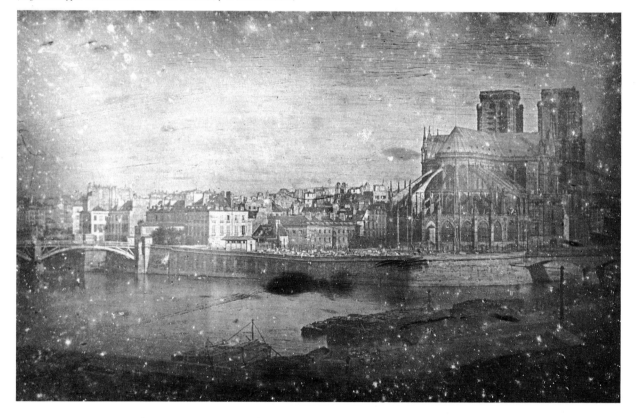

4

size (16·5 × 21·5 cm) of the Daguerre–Giroux camera would also have to be reduced, by three quarters or more. Clearly, too, better lenses could dramatically reduce the exposure, for the uncorrected meniscus lenses produced by Chevalier and Lerebours for the Daguerre–Giroux apparatus gave a sharp image only when stopped down to 1:14 and 1:16 respectively. Joseph Petzval of Vienna designed a superlative lens combination with an aperture of 1:3·6, which was twenty times faster, and Friedrich Voigtländer, then also of Vienna, put it on the market on 15 November 1840. In January 1841 Franz Kratochwila of Vienna announced that by exposing an iodized plate to a mixture of chlorine and bromine vapours its sensitivity could be enhanced by a factor of five. This was the first accelerating process to be made available to the public.

In May 1840 Alexander Wolcott, a New York manufacturer of dental supplies, patented a new form of camera, in which a concave mirror reflected the image of the sitter on to the sensitized plate, thus dispensing with a lens altogether. This greatly reduced the exposure time, and its effect was reinforced by the ingenious lighting system worked out by Wolcott's partner John Johnson. A trough of plate glass filled with a solution of copper sulphate was installed in the studio, and mirrors fixed outside the window directed the sunlight through the trough on to the sitter. The blue liquid acted as a filter, increasing the proportion of actinic rays, shortening the exposure and also reducing the heat of the sunlight. The combination of these two devices had enabled Wolcott and Johnson to open a public portrait studio in New York City early in March 1840. It was the first in the world.

In London Richard Beard, who bought Daguerre's patent outright one year later, heard of the success of Wolcott and Johnson and asked them

to come to England and assist him in creating a similar studio in London. Beard bought the patent for Wolcott's mirror camera and had a glasshouse constructed on the roof of the Royal Polytechnic Institution. The complicated American lighting system was not necessary as the studio was glazed with blue glass. Its opening on 23 March 1841 was a huge success; it was the first photographic studio in Britain, and quite probably the first in Europe.

Sitters at Beard's studio were advised on what they should wear – avoid black, no white frills – and suitable clothes and changing-rooms were provided. Maids were on hand to make the necessary alterations. The sitter's face was then made up and his or her head clamped in a headrest. (This device antedated photography, being a prerequisite of the portrait painter's studio. It continued in use in photographic studios until the turn of the century.) Various improvements had brought exposures down to between one and a half and three minutes, depending on the weather and the time of day. This was still excessively long from the sitter's point of view, but people flocked to Beard's studio, and business was beyond his wildest dreams. The portraits were considered rather in the light of miniatures, as befitted both their size (4 × 6 cm) and their cost. They were agreeably framed in red morocco cases lined with velvet. Plain photos were one guinea, hand-coloured photos were two. With each additional person the risk of movement on the part of the sitters increased, so groups were proportionally more expensive. Within two years the mirror camera was replaced by a Voigtländer lens, exposure times and prices were reduced, while portraits doubled in size. The mirror camera had served its turn, for lenses provided sharper and larger images.

The early daguerreotype portraits

had much greater impact than pictures of buildings or views; the latter are indeed somewhat rarer, at least as regards photographs of sites in Europe. The portraits were exact copies of life. The age-old dream of possessing the very image of one's beloved, relatives or friends could now be realized, and the detail of dress and jewellery in the representation enhanced the likeness. Elizabeth Barrett Browning wrote to Mary Russell Mitford in 1843 before her marriage, 'I would rather have such a memorial of one I dearly loved than the noblest artist's work ever produced.' Hans Andersen was travelling in southern Germany when he saw, at Augsburg, some of the earliest daguerreotype portraits. 'Made in ten minutes . . . It seemed to me like magic. The daguerreotype and the railway, these two new fruits of our age, were a boon to me on my journey,' he wrote in his diary.

Until 1842 only plain backgrounds were used for portraiture, but in that year Antoine Claudet, a Frenchman by origin, introduced painted backgrounds (see plate facing p. 70). Claudet had opened the second daguerreotype studio in London, three months after the launching of Beard's; his studio was a glasshouse on the roof of the Royal Adelaide Gallery. In 1851 Claudet moved to 107 Regent Street. Regent Street was at that time a very exclusive business quarter, and Claudet had 107 reconstructed in Renaissance style by Sir Charles Barry, the architect of the new Houses of Parliament. The interior was decorated by well-known French artists with murals illustrating the history of photography and the various photographic processes and their inventors; medallion portraits featured luminaries of photography's artistic and scientific past. By general consent Claudet's was the most elegant and luxurious establishment of its kind in Great Britain.

In the year in which his new studio opened, Claudet won the highest

award for portraiture at the Great Exhibition in London. This set the seal on his reputation as the leading daguerreotypist in Britain; his artistic status was compared to that of the fashionable portrait painter Sir Thomas Lawrence. It was therefore only to be expected that he should receive a royal command to take portraits of Queen Victoria and other members of the royal family (1853); he was subsequently appointed Photographer-in-Ordinary to the Queen.

Claudet was the first photographer to produce daguerreotypes for Sir David Brewster's lenticular stereoscope, and these had the good fortune to attract the curiosity of Queen Victoria and Prince Albert at the Great Exhibition. The royal enthusiasm for the astonishing illusion of space and depth provided by the stereoscope proved most beneficial to sales; half a million stereoscopes were sold within the next five years, and the production of double pictures or stereographs (mostly by the collodion process) went on at a great rate.

In the late autumn of 1846 William Edward Kilburn opened a daguerreotype studio, also in Regent Street. (With the exception of Claudet, who had a prior arrangement with the patent agent, every daguerreotypist in England and Wales had to have a licence from Richard Beard. Like property tax, the fee was fixed according to the locale of the studio and the probable annual revenue that the proprietor would derive from it.) Kilburn's portraits quickly established a considerable reputation, and in April the following year he too was honoured with a royal command. He photographed the Queen and the Prince Consort in the conservatory of Buckingham Palace, and in acknowledgement of his work was appointed Her Majesty's Daguerreotypist. This episode is to be contrasted with the experience of Daguerre, who five years before had

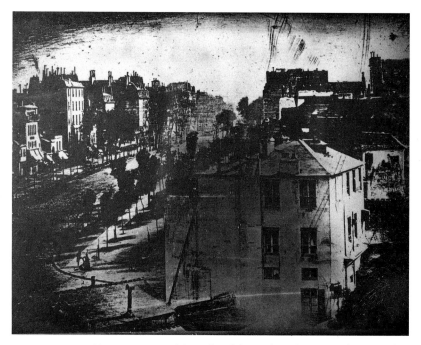

Louis Jacques Mandé Daguerre: *View of the Boulevard du Temple, Paris, c.* 1838 (daguerreotype, Bayerisches Nationalmuseum, Munich)

received a similar commission from Louis-Philippe. The King had posed in the garden of the Tuileries. A German newspaper reported that 'His Majesty sat with his face turned to the sun, wearing black, with a white cravat, and no hat. The operation lasted five minutes', and was a complete fiasco. Daguerre never subsequently referred to this event. Only when, in 1843, Claudet spent several months in the French capital portraying notabilities was the King at last satisfied that the process to which he had given his blessing worked even with himself.

In France the first professional portrait daguerreotypists were probably Susse Frères, N. M. P. Lerebours and the Bisson brothers, Louis and Auguste. All of them opened studios in Paris in the second half of 1841, after Arago had told the Académie des Sciences of the acceleration of the daguerreotype

process that Claudet had obtained by treating the plate with chlorine vapours as well as the usual iodine. (Arago's communication took place on 7 June 1841.) Claudet's method would seem to have been more effective than that of Kratochwila, for quarter-plate portraits (4 × 5·5 cm), it was stated, could now be taken with exposures of five to twelve seconds in the shade and one to four seconds in the sun. In 1839 and 1840 Lerebours had sent a number of amateurs abroad with daguerreotype equipment; they were to send their results back to him. A selection of these was published, between 1841 and 1843, in the first photographic travelogue, the 'Excursions daguerriennes'. The views were engraved, and the engraver freely added carriages and figures to enliven the scenes. The enterprising Lerebours also sensed that there was money to be

made with nude studies, which were euphemistically referred to as 'académies' in order to suggest a public made up of artists and collectors. Others, who produced pornography *simpliciter*, preferred to remain anonymous. For young artists, who would otherwise have had to pay their models by the hour, the photographs were a considerable saving. Delacroix, Ingres, Degas, Courbet and Durieu all occasionally painted from photographs; the first and last named were founder members of the French Photographic Society. Delacroix considered photographs 'treasures for an artist', and in 1854 confided to Constant Dutilleux, 'How I regret that such a wonderful invention should have arrived so late as far as I am concerned. The possibility of studying such results would have been an influence on me of which I can only get an idea from the use they still are to me.'

In America the use of machine-polished plates for daguerreotypes had given the photographers of that country a reputation for technical superiority. Their portraits were often less conventional than those of their European contemporaries, and they photographed not only people but also factories, machines, steamships, landscapes urban and pastoral, and events. Such photographs are often of considerable historical interest as the only contemporary representations we possess. Since Americans did not take to the calotype and wax-paper methods, the change-over to the collodion process took place as late as 1865, some ten years later than elsewhere.

Only eighteen photographs by Daguerre have survived. On his retirement in 1840 he moved to Bry-sur-Marne, a few miles east of Paris, where he had bought a small property; this was subsequently destroyed in the Franco-Prussian War of 1870–71. The vital improvements to his process had all been contributed by experimenters attracted to photography from other fields. Early in 1841, however, Daguerre claimed to have found a method that would make it possible to take instantaneous pictures of public ceremonies, markets, battles and so on. As portraiture itself was at this juncture technically impossible in France, the claim understandably caused a great deal of excitement. On investigation, it proved wholly without foundation. The old showman had been attempting a comeback. Three years to the day after this first announcement, Daguerre alleged he had discovered new and more sensitive substances that would make it possible to photograph a galloping horse and birds in flight. Exposures as rapid as one thousandth of a second were still some way off, so Daguerre perforce kept the world of photography waiting for details of his method. Eventually, in 1844, he published a brochure, specifying the chemicals required. The wish had again proved father to the thought; the chemicals listed were not even as sensitive as those already in use.

Daguerre died suddenly after a heart attack on 10 July 1851. Three months previously the English portrait sculptor Frederick Scott Archer had published details of his unpatented collodion method. Superseding daguerreotype and talbotype alike, it reigned supreme for some thirty years.

Helmut Gernsheim

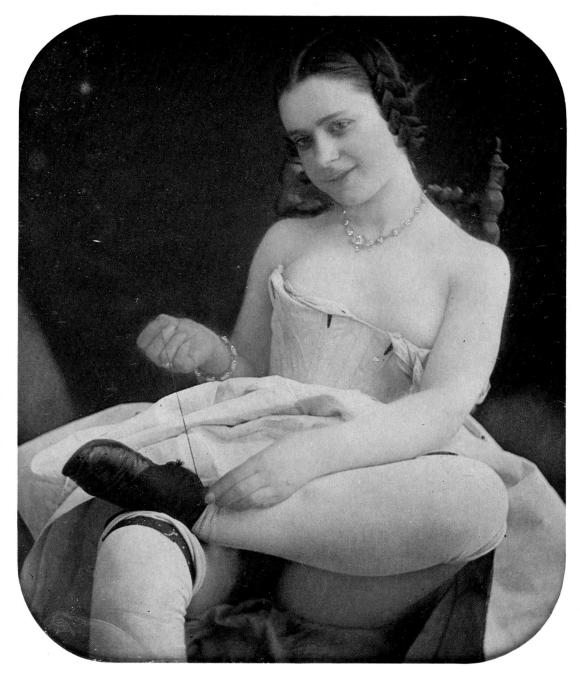

Anonymous, French: *Woman tying shoelace, c.* 1855 (daguerreotype, inside frame 5·6 × 6·5 cm, half of a stereograph, Richter Collection)

The Dawn of Photography: The Daguerreotype Process and Its Consequences

ON 9 MAY 1839 THE FAMOUS scientist Sir John Herschel, visiting Paris, was shown some daguerreotypes by Daguerre himself. He was deeply impressed, and wrote back to fellow scientist William Henry Fox Talbot:

It is hardly saying too much to call [daguerreotypes] miraculous. Certainly they surpass anything I could have conceived as within bounds of reasonable expectation. The most elaborate engraving falls far short of the richness and delicacy of execution, even gradation of light and shade is given with a softness and fidelity which sets all painting at an immeasurable distance.[1]

On 19 August that year came the official announcement by Arago of Daguerre's and Niépce's invention, and with it began photography's triumphant progress through the world. With the perspective of 150 years, we recognize in it one of the most epoch-making inventions in the history of mankind.

The first photographers

The livelihood of miniature painters was directly threatened by the invention of photography, and they figure prominently among the early practitioners. Not all had been masters of their first art, and Charles Baudelaire remarked that the new industry was becoming 'the refuge of failed painters with too little talent'. This was a little wide of the mark. In America, where, unlike Britain, no licence was required, photography seemed to offer a high road to financial betterment, requiring as it did neither a major outlay nor a great deal of instruction. Photographers were consequently recruited from every walk of life; they were engravers, opticians, engineers, jewellers, watchmakers, locksmiths, carpenters, dentists and even masons, lampshade

Anonymous: *Joint meeting of the Academies of Sciences and Fine Arts in the Institute of France, Paris,* 19 August 1839 (engraving, Gernsheim Collection, University of Texas, Austin)

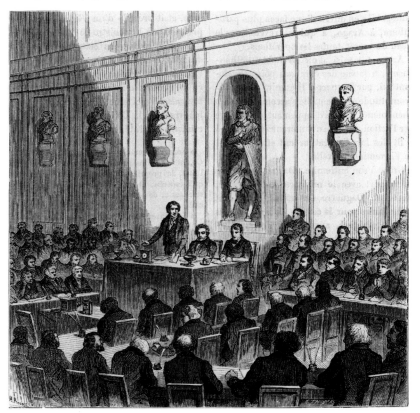

and window-blind manufacturers, grocers and tinkers. But very few – some five per cent – survived in their new profession for as long as ten years, and for as many as fifty per cent it was the occupation of a single year.

The process and the studios

The making of a daguerreotype was a complicated and time-consuming process. Neither the chemicals nor the silver-coated copper plates were of uniform quality, and this, together with the problem of judging the exposure, made many exposures unusable. In 1854 the London daguerreotypist Claudet, who was renowned for his mastery of the medium, stated, 'The great number of elements acting in the daguerreotype process . . . and the influence of various unknown causes . . . render the process very difficult and uncertain. So many conditions are requisite to a successful operation that, indeed, it might be said that failure is the rule and success the exception.'[2]

The fine layer of silver on the copper plate had to be highly burnished. This process, called 'buffing', was perfected in America, where the polishing head, whose surface was of deerskin, was often power driven. Silk or velvet was used for the final polish. The plate was then sensitized by being exposed first to iodine vapours, then to fumes of chlorine and/or bromine in a special coating box. These operations had to be carried out in a semi-dark room. The chlorine and bromine 'quickstuff' or 'accelerators' so enhanced the sensitivity of the plate that from 1841, used in conjunction with new and improved lenses, they made photographic portraiture possible. As the fumes reacted with the silver, a series of beautiful colours appeared on the plate: several shades of yellow, then orange, pink, red, purple, deep blue and finally green. The skill lay in

knowing when to stop this spectral procession; the plate attained its highest degree of sensitivity during the yellow, orange and light-red phases.

It is not widely appreciated today how dangerous the chemical side of photography was. The process described above is a veritable witch's brew; every chemical cited is toxic. Chlorine was one of the poison gases employed during the First World War; iodine irritated the skin; bromine had similar superficial effects and also attacked the nervous system, resulting in delirium, hallucinations, tremors and worse; the mercury vapours used in developing were lethally poisonous and caused kidney failure ('Bright's disease', as it was then known). Photographers lost their teeth and also suffered from fits of shyness and anxiety, difficulties in speaking and moving, and progressive deafness and blindness. The famous Hamburg photographer Stelzner went blind at fifty, when he still had forty years to live. The dark oxidation marks on the plate's silver surface were removed by the use of a solution of potassium cyanide; the process is still used today, but only under the strictest laboratory conditions. The chemical stench of the daguerreotypist's work-room was overpowering, and even today original coating boxes in photographic collections give off a distinctive odour. It is a wonder that so few daguerreotypists died in the exercise of their art. Many, however, turned the chemical side of the operation over to assistants, whose fate we simply do not know.

The plate sensitized by this lethal process was then slipped into the camera, which stood on a rotating platform on a stand. There were no shutters; the exposure was manual, and consisted of removing and replacing a cap on the lens. A daguerreotype, like the reflection in a mirror, is a horizontally reversed image, but this is unlikely to strike the

viewer unless the picture contains lettering or shows a well-known sight. The reversal was often corrected by placing a mirror or second lens in front of the first.

The exposure varied from three to forty seconds, depending on the sensitivity of the plate, the quality of the lens and the intensity of the light. To help the sitters to remain still, they were often asked to place their heads in the jaws of a heavy metal headrest. Then, usually facing into the sun, they had to hold 'still as death', a process often assisted by resting their chins on their hands. It was a little difficult under these conditions to maintain a relaxed and pleasant expression. 'My eyes were made to stare until the tears streamed from them, and the portrait was of course a caricature,'[3] records a victim of Claudet's studio. Photographers grappled with this problem as best they might – 'ladies . . . we will give a recipe for a pretty expression of the mouth . . . let them place it as if they were going to say, "Prunes"'[4] – but many sitters were disappointed by their tense-looking appearance: 'my picture looks like the devil'.[5] The implacable honesty of the daguerreotype, which could not be retouched, was no ally of human vanity, and the possibility of eliminating wrinkles and other facial flaws by judicious retouching was one of the advantages of the collodion process that eventually supplanted the daguerreotype.

In his *Journal* in 1841 Ralph Waldo Emerson wrote about his own experience of sitting for a portrait:

Were you ever daguerreotyped, O immortal man? And did you look with all vigour at the lens of the camera, or . . . a little below it, to give the picture the full benefit of your expanded and flashing eye? And in your zeal not to blur the image, did you keep every finger in its place with such energy that your hands became clenched as for fight or despair, and in your resolution to

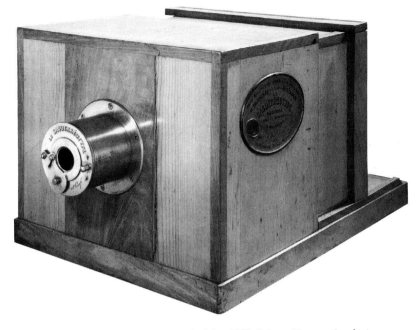

Camera made by Alphonse Giroux to Daguerre's design, 1839 (Science Museum, London)

keep your face still, did you feel every muscle becoming every moment more rigid; the brows contracted into a Tartarean frown, and the eyes fixed as they are fixed in a fit, in madness or in death? And when, at last, you are relieved of your dismal duties, did you find the curtain drawn perfectly, and the hands true, clenched for combat, and the shape of the face or head? – but, unhappily, the total expression escaped from the face and the portrait of a mask instead of a man?[6]

Clearly in those days a sitting was something exciting and photography still somewhat miraculous. The reaction of the client was also unpredictable, as witness the events that befell operator Gabriel Harrison of John Plumbe's New York studio. He takes up the narrative in the *Photographic Art Journal* of March 1851:

It was in the year 1844 when operating for Plumbe . . . one morning [there was]

conducted into room no. 8, which happened to be my sanctum sanctorum, a rather tall, slick, shingle-like specimen of the genus Homo, feminine gender, whose every look and motion indicated her to be an Old Maid. After certain movements peculiar to such productions she drawled out: 'Well, Mister, I want to have my dogre-o-type taken and put into a case with a red cover.'

I assured her it should be done and retired to prepare the plate, leaving her seated in the operating chair. I soon returned and after fifteen minutes hard labour succeeded in [obtaining] a somewhat flattering position; but just as I was about to draw the slide, I observed that her breathing moved her head sufficient to prevent a good result in the camera, and remarked to her to be careful and not suffer her respiration to move her head while the picture was being taken; I then drew the slide and retired to my sideroom.

At the expiration of about sixty seconds, I heard to my dismay, a loud drawling, Oh me! I rushed into the room, John after me,

when lo and behold, there she lay, stretched out at full length on her chair, her head back, her mouth livid with blue, and uttering just audibly – 'I can't hold my breath any longer.'

This was enough for John, who, thinking that she was either going to faint or die, flew to my stand, seized a large bowl of hyposulfite solution, and returning, dashed the contents into her face. The screech that followed was truly awful.

She sprang to her feet and flew at poor John with the ferocity of a tigress, around the room they went, he throwing down camera stands, chairs, tables, and everything that came in his way, to impede her progress. At last he darted out the door, rushed down the stairs and through the reception-room, where there were many persons waiting for their pictures, shouting at the top of his voice, 'Mad woman! mad woman!'

I do not know whether they took the cry for mad dog or not, but certain it is, those in the gallery were in an instant following him down the stairs in the most frightening consternation. A large mob was soon collected around the door, and when I descended I found three or four gentlemen endeavouring to raise a Lamberthian lady, who, in her flight not being able to descend sufficiently rapid had rolled from the top to the bottom, without much injury, however, to her immensity. Soon the tempest of the excitement was calmed, and the poor operator whose labours in his fascinating art the world can never fully appreciate, was wending his way homeward.[7]

The development of the exposed plate was effected by subjecting it to the vapours of heated mercury. Few developing rooms were adequately ventilated, and the stench of this highly toxic chemical permeated the air in such concentration that the gold watch-chains of photographers and assistants would be coated with amalgam. The image was fixed by immersion in a solution of hyposulphite of soda, then washed in distilled water. In 1840 Hippolyte-Louis

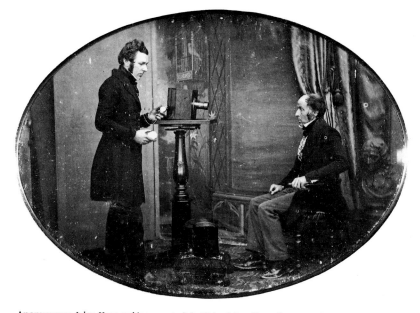

Anonymous: *Jabez Hogg making a portrait in Richard Beard's studio*, 1843 (daguerreotype, National Museum of Photography, Film and Television, Bradford)

Fizeau introduced the 'gilding' method of gold-toning the plate in a gold-chlorite solution, which enhanced the brilliance of the photograph. It also helped prevent the oxidation of the silver. The discoloration produced by tarnishing affects many daguerreotypes today, but I take this opportunity to point out that one should *never* attempt to remove these marks by cleaning or polishing the plate. In particular, the use of 'silver dip' may simply efface the image altogether. Restoration should be left to the experts!

The dependence of the first studios on plentiful natural light meant that many were built on the top floors of existing buildings – on Broadway in New York and Regent Street in London – and had glass roofs or large skylights. The unstable and often overcast London weather was obviously not ideal for all-year-round activity.

The reception-rooms of the better-established studios were often extremely elegant and comfortable. It was usual to have a separate dressing-room for the ladies, referred to as the 'parlour'. The reception-room also acted as a display space, in which portraits of the famous were assured a prominent place. In 1853, writing in his *Journal of the Daguerreotype*, Humphrey described the reception-room of the famous Broadway studios of Mathew B. Brady:

The floors are carpeted with superior velvet tapestry, highly coloured and of a large and appropriate pattern. The walls are covered with satin and gold paper. The ceiling [is] frescoed, and in the centre is suspended a six-light gilt and enamelled chandelier, with prismatic drops that throw their enlivening colours in abundant profusion. The light through the windows is softened by passing the meshes of the most costly needleworked lace curtains, or intercepted, if occasion requires, by shades commensurate with the gayest of palaces, while the golden cornices, and festooned damasks indicate that Art dictated their arrangement. The harmony is not in the least disturbed by the superb rosewood furniture – tête-à-têtes, reception and easy chairs, and marble-top tables, all of which are multiplied by mirrors from ceiling to floor. Suspended on the walls, we find Daguerreotypes of Presidents, Generals, Kings, Queens, Noblemen – and more nobler men [sic] – men and women of all nations and professions.[8]

Hand-tinting

Well before the invention of colour photography, daguerreotypes and other early photographic images sported a wealth of applied colour. The hand-tinting of the 1840s and 1850s, where it combined with well-composed, well-lit pictures, sometimes created masterpieces, and the flesh tones of stereoscopic nudes are often astoundingly natural and realistic (see plate facing p. 94).

When the first daguerreotypes were exhibited in 1839, it was regretted that the new invention did not record life in its true colours; monochrome, it was felt, did not give an adequate likeness, and the photographers set about introducing colour. As early as 1852 Beard patented a hand-colouring technique. Colour both improved the resemblance and added warmth to the daguerreotype's metallic tones.

But the tinting of daguerreotypes did not meet with universal approval. For Arago, the use of pigment on the silvery daguerreotype was a desecration: 'to hand-tint a lovely image, even by the hand of an artist of repute, is as if one should set a sign-painter to retouch the wings of a butterfly'. He was not alone in his opposition; some of the most renowned photographers, among them Southworth and Hawes, were of the same opinion. Critics condemned hand-tinting as 'pandering to the taste of the public', and compared it to

'illuminating an engraving by Rembrandt';[9] 'the qualities of the beautiful gradations of tone and . . . a harmony of light and shade . . . all these qualities become submerged in this absurd paste of colours'.[10]

Hand-tinting was no less popular for these objections. It was an exacting and time-consuming task, generally carried out by former miniature painters, and the customer was often charged extra. The colourist, using a fine paintbrush, coated the delicate surface of the plate with a very thin film of dilute isinglass or gum arabic, and left it to dry. Then he or she would breathe on the plate to make it sticky and, using an extremely fine camel-hair brush, meticulously apply dry powdered pigment to the image. Occasionally things went wrong, and the image emerged from the colourist's hand 'clouded and spoilt'. But the hand-tinting professionals were often absolute masters; one might easily think the colours integral to the photographic process. The character of a daguerreotype cannot be properly appreciated in monochrome reproduction, and the plates here have been produced with the best possible four-colour printing.

Portraits in which the sitter wore jewellery gave rise to special techniques: the items could be picked out on the plate with real gold or the photographer's assistant could use a sharp-pointed instrument to expose a part of the silver of the plate. Under strong illumination this produced a sparkle apparently emanating from the diamonds or pearls illustrated.

The images

The fascination of a daguerreotype is not fully manifest until one holds it in one's hands. It is difficult to see the image clearly unless the mirror surface of the daguerreotype is tilted at an angle and held against a dark surface,

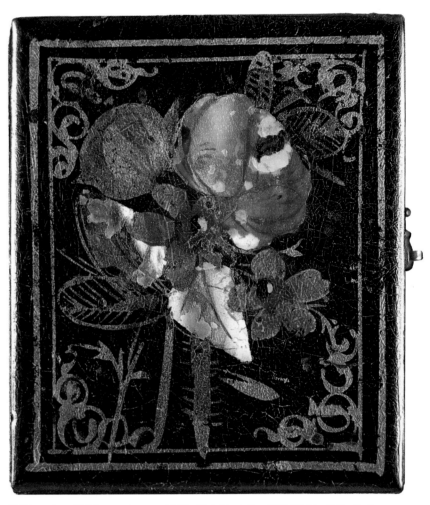

British papier-mâché daguerreotype case inlaid with tortoiseshell, c. 1850 (Richter Collection)

otherwise the shadows in the photograph reflect the light and reverse the tones. Reproduction is also difficult. The plate must be side-lit, but care must be taken not to show up the slight diagonal striations caused by polishing. To avoid reflections, the camera and its surrounds must be completely blacked out with dark cloth or cardboard, leaving only a hole for the lens. The highlights of a daguerreotype consist of a whitish deposit (silver-mercury amalgam particles), while the shadows are of reflective silver. The image of a daguerreotype always seems unstable and fluid; it is unique among photographs in this elusive quality.

The picture on the plate is exceedingly delicate, and careless handling is liable to cause irreparable damage. It is all but invulnerable to light, however, and in their 150 years of existence daguerreotypes, unlike

paper prints, have proved immune to fading.

To protect the surface against damage and oxidation from sulphur-polluted air, the plate was kept under a piece of glass; a paper or metal passe-partout mat or gilded or brass cut-out prevented the glass from abrading the surface it screened. The three elements were sealed together by binding the edges with gummed paper. After 1850 an ornate brass frame or 'preserver' was used to hold this sandwich tightly together in an ornamental fashion. The thin gilded or brass cut-out mats were originally of simple oval, octagonal or other design. Later the mats became more ornate, and this provides some clue as to date. Outside Britain and America the plates were framed by cut-out paper passe-partouts; the underside of the glass was sometimes painted black to form a frame.

In Britain and America the sandwich of plate–mat–glass was inserted into a style of case originally devised to hold miniatures. Two shallow boxes were hinged on one side, and on the other were two hooks or a hinge-clasp fastener. The image was normally fitted into the right-hand frame, but occasionally both frames contained pictures. The more expensive wooden cases were bound with leather, for the most part goatskin; these morocco cases eventually gave way to cheaper models covered with embossed paper. After 1850 cases of a great variety of different shapes and materials came into use; among the most exotic were those made in black papier mâché, inlaid with tortoiseshell and brilliantly coloured 'aurora' mother-of-pearl. Rarer still are the papier-mâché cases with a fine hand-painted landscape on the cover. Thicker cases were often made to resemble miniature books, while at the other end of the scale very small daguerreotypes of oval shape were worn in brooches and lockets.

In 1854 thermoplastic 'union cases', so called because the word 'union'

appeared in the patent, were introduced in America, and this is thought to be the very first industrial use of thermoplastics in the world. (They are sometimes mistakenly identified as being made of gutta-percha.) An immediate popular success, the cases were highly ornate and their covers were decorated with a considerable variety of detailed and exquisite designs – some eight hundred are recorded; the motifs were naturalistic, historical or patriotic.

The photographic quality and definition of a well-made and well-preserved daguerreotype are beyond compare. Despite the technical limitations of the daguerreotype process, for example its inability to record moving objects, 150 years of photographic endeavour have given us no more elegant or moving product. To be persuaded of this, it is sufficient to look at an original; there is such clarity in the image. In the early 1840s people seeing a daguerreotype for the first time reacted with disbelief. Edgar Allan Poe remarked on this precision of detail (1840): 'If we examine a work of ordinary art by means of a powerful microscope, all traces of resemblance to nature will disappear – but the closest scrutiny of the daguerreotype discloses only a more absolute truth, more perfect identity of aspect with the thing represented.'[11]

Daguerre himself, when asked how such an image could have been produced other than by a painter's hand, told people to take a magnifying glass to it. A painting scrutinized in this way dissolves into brush-strokes, whereas the daguerreotype remains a detailed reflection of nature. In the *Literary Gazette* of 12 January 1839 we find:

[the daguerreotype] is wonderful. But who will say that it is not the work of some able draughtsman? Who will assure us that they are not drawings in bistre or sepia? M. Daguerre answers by putting an eye-glass

into our hand. Then we perceive the smallest folds of a piece of drapery; the lines of a landscape invisible to the naked eye. With the aid of a spying-glass we bring the distances near. In the mass of buildings, of accessories, of imperceptible traits which compose a view of Paris taken from the Pont des Arts we distinguish the smallest details; we count the paving-stones; we see the humidity caused by the rain; we read the inscription on a shop-sign.[12]

Treasured keepsakes

The great majority of daguerreotypes – around ninety-five per cent – were portraits. From the very beginnings of the art, the sitters wished to be able to offer a likeness to those they loved, and personal photographs were highly treasured. Thus Jane Welsh Carlyle wrote in a letter of 1859:

Blessed be the inventor of photography! I set him above the inventor of chloroform! It has given more positive pleasure to poor suffering humanity than anything that has 'cast up' in my time . . . this art by which even the 'poor' can possess themselves of tolerable likenesses of their dear absent ones . . . I have often gone into my own room, in the devil's own humour . . . and, my eyes resting by chance on one of my photographs of long-ago places or people, a crowd of sad gentle thoughts has rushed into my heart and driven the devil out, as clean as ever so much holy water and priestly exorcism could have done.[13]

Many who could not have afforded to have themselves portrayed by a miniature painter could now afford their own likeness, and this possibility was enthusiastically welcomed. In 1843 Elizabeth Barrett Browning wrote to Mary Russell Mitford:

Do you know anything about that wonderful invention of the day, called the Daguerreo-type? Think of a man sitting down in the sun and leaving his facsimile in all its full com-

pletion of outline and shadow, steadfast on a plate, at the end of a minute and a half! The Mesmeric disembodiment of spirits strikes one as a degree less marvellous . . . It is not merely the likeness which is precious in such cases – but the association and the sense of the nearness involved in the thing . . . the fact of the very shadow of the person lying there fixed for ever! It is the very sanctification of portraits.[14]

The nineteenth century was a time of travels and emigrations, and photographic portraits were naturally taken along as reminders of the loved ones staying behind. An early advertisement puts the point thus: 'Nobody who travels knows when he shall return. Therefore he ought to leave something behind for his friends to remember him by. What can be more appropriate than a Daguerreotype?'[15] Daguerreotype portraits did not always survive their subjects. Today their value is artistic or historical, and few indeed are those who can say, 'This was my great-grandfather!'

Daguerreotypomania – Europe and America

After Arago's announcement in August 1839, Parisians rushed to try out the new wonder, and enthusiasts taking daguerreotypes were so numerous that by December the press had already coined a term for the phenomenon: 'daguerreotypomania'. Only a few years later the first portrait studios were set up. As Charles Baudelaire put it in 1859, 'From that moment onwards, our loathsome society rushed, like Narcissus, to contemplate its trivial image on a metallic plate. A form of lunacy, an extraordinary fanaticism took hold of these new sun-worshippers.'[16]

In 1845 in Paris alone 2,000 cameras and 500,000 plates were sold. The complete apparatus – camera, lens,

Théodore Maurisset: *La daguerréotypomanie*, December 1839 (lithograph, Gernsheim Collection, University of Texas, Austin)

chemicals and boxes for development – cost around one thousand francs, a sum at least equivalent to the price of professional equipment today. In England and Wales the expansion of photography was curbed by the additional cost of obtaining a licence from Richard Beard. Daguerre had patented his process in England shortly before Arago's announcement that France was making a gift of the invention to the world at large; Beard bought the patent in June 1841 for eight hundred pounds. His monopoly caused a certain resentment, and in 1851 only fifty-one photographers were officially registered.

It was in America that the daguerreotype enjoyed its fullest and longest-lived success. The nation of free enterprise immediately perceived the commercial potential of the new invention, and this emphasis was perhaps the dominant one. The word

initially caused some confusion. The *New York Observer* discussed the problem of pronunciation in December 1839: 'Dog-gery-type says one, Dag-gery-type says another, Daygwerryotype says a third . . . the right pronunciation . . . is Dar-ger-row-type',[17] and even Edgar Allan Poe felt it necessary to point out that 'this word is . . . pronounced as if written Dagairraioteep'.

The world's first professional studio was opened by Alexander Wolcott in 1840 in New York. In a country where portrait and miniature painting had been condemned as luxuries for the rich, the crisp realism of the daguerreotype was welcomed as a democratic art, and soon thousands of Americans were trying to earn their livelihoods by photography; by 1853 more than three million daguerreotypes were being exposed annually. The centres of the industry

15

were Philadelphia, Boston and New York.

Broadway was the prestige location for such businesses. In 1853 there were more studios on Broadway alone (thirty-seven) than in London, and about a thousand New Yorkers worked as photographers. Sunday was the great day for having one's portrait taken and, although the portrait studios in New York City outnumbered the total in Great Britain, waiting-rooms were crowded. The quality of the machine-buffed plates and the intensity of the light were conducive to high artistic standards, and when Southworth and Hawes, who were based in Boston, boasted that they took the best daguerreotype portraits in the world, their claim was not an idle one. Their individual lighting techniques made for portraits in which the individuality of the sitter was strongly expressed. But they, together with such photographers as Brady of New York, were the exceptions; most American photographers made simple and straightforward portraits of solemn and rather tense-looking sitters. The uniformity of these images was described in *Gleason's Pictorial and Drawing Room Companion* in 1853:

If you have seen one of these [studio display] cases you have seen them all. There is the militia officer in full regimentals . . . there is the family group, frozen into wax statuary attitudes and looking . . . as if . . . assembled for a funeral . . . the fast young man, taken with his hat on and a cigar in his mouth; the belle of the locality with a vast quantity of plaited hair and plated jewellery . . . the best baby . . . the intellectual . . . and the young poet . . . There is something interesting in the very worst of these daguerreotypes because there must be something of nature in all of them.[18]

Towards the end of the daguerreotype era more than 3,100 professional photographers were working in America, and every town had its own studio. In the 1850s factories in a town named Daguerreville on the Hudson were producing some three million daguerreotype plates every year.

The great exhibitions

During the nineteenth century industrial exhibitions were held from time to time in France, Britain and America, and the 1844 Paris Exhibition saw the first major display of daguerreotypes; it numbered over a thousand works. The 1851 Crystal Palace Exhibition in London, a 'Great Exhibition of the Works of Industry and of all Nations', symbolically marked the mid-point of the century. The show of daguerreotypes there was seen by a large international public; among the photographers represented were Claudet, Beard, Kilburn, Whipple, Mayall and Brady. Photography had received its official consecration. In the world's first international photography competition, which accompanied the exhibition, three of the five prizes were carried off by American photographers.

Stereoscopic images

Also exhibited for the first time at the Great Exhibition was Sir David Brewster's invention, the lenticular stereoscope, the principle of which had been known before the invention of photography.

Our eyes are set about 6·5 centimetres apart, and our perception of depth derives from their combined viewpoints. By placing two lenses at a distance of 6·5 centimetres, the photographer could take two views of the same scene exactly as our eyes would see it. The two images set 6·5 centimetres apart in a frame constitute a stereoscopic daguerreotype or stereograph. When this is viewed through a stereoscope, each eye picks up one of the images, and they are merged by the brain's visual apparatus into a single three-dimensional image.

The first stereographs used two cameras side by side or a single camera that was moved the requisite distance to one side for a second exposure. The latter method was effective for stills, but the slightly different posture of the model in each of the exposures tends to betray this process where it has been used with a human subject. The first stereoscopic cameras were built in or around 1855 by Ninet in Paris; one exposure simultaneously produced two slightly different images on a single plate (normally 162 × 144 cm).

The stereographs were viewed in a box-shaped hand viewer; light was reflected on to the images by a mirror hanging on the same plane as the plate. In 1852 John F. Mascher of Philadelphia developed a miniature case that contained on the one side a stereograph and on the other a folding stereoscope, and similar pocket stereoscopes, incorporating the stereograph, were introduced in London by Claudet and Kilburn in 1853.

Although many excellent daguerreotype stereographs were made in the mid-1850s, the process was not ideal for stereoscopy. The elongated plate was bulky and fragile, and the photos were expensive, while the silvery surface produced reflections that interfered with the stereoscopic effect. The widespread popularity of stereoscopy came with the collodion process, which made inexpensive paper prints possible.

Nude photography

In photography no less than in painting and sculpture the female nude was, almost from the first, a favoured subject. The reduction in exposure times was sufficient by 1841 to allow for nude studies, and in that year

Lerebours, who had opened a studio in Paris, advertised the first photographic 'académies'.

Soon after, the first erotic daguerreotype stereographs appeared on the Paris market. These were almost invariably anonymous. Only a few photographers acknowledged production of daguerreotype nudes: Moulin, Belloc, Braquehais, D'Olivier and Vallou de Villeneuve, and they tended to eschew the more overt commercialism of the stereograph. Paris was at first the unchallenged centre of the industry of the erotic photograph, exporting its products throughout Europe. The market in daguerreotype stereographs reached its peak around 1855; at this stage the photographs were still fairly expensive, though within the means of the well-off middle classes.

In Paris erotic stereographs could easily be obtained but could not be publicly exhibited. Elsewhere they were treated as pornography. Nudity in painting or sculpture could be introduced under the cloak of allegory, history or mythology, but was otherwise considered offensive. In painting realism could be mitigated; in the photograph all was revealed. The clarity, detail and realism of the daguerreotype nude were therefore considered more than a little scandalous. The general public took little or no account of the distinction between nude studies for artists and stereographs for titillation, and only with the advent of later processes was it possible to retouch a photograph to make it resemble a drawing or etching. British photographers, influenced by the moral climate, generally did not attempt daguerreotype nudes, though with the advent of the collodion process, London too became a source of anonymous pornography. Few nude daguerreotypes were taken in America, for similar reasons (it is rumoured that certain studios at the southern end of New York's Broadway made the

occasional one or two), and the French exporters prospered accordingly. Very few daguerreotypes of male nudes have survived, and those that have often show that classical references in the form of pillars or painted landscapes were required to legitimize the genre. Today's viewer may be struck by the degree to which the overt commercialism of the erotic daguerreotype produced photographs in which the personality of the model is serenely conveyed.

Travelling photographers

Itinerant daguerreotypists drove from town to town in their horse-drawn studios or 'saloons'. In 1840 the Swiss painter and engraver Johann Baptist Isenring of St Gallen toured southern Germany in this way, and exhibited the first daguerreotypes seen in Munich. His converted wagon served him as home, studio and laboratory. The travelling photographer might also on occasion hire a well-lit room and set up his camera there, making his 'dark-room' by stringing a blanket across a corner.

The photograph was clearly well suited to producing accurate accounts of remote and exotic places, and photographers touring the world catered to a curiosity already formed by the reports of explorers, missionaries, soldiers and traders. Although the first such photographers were amateurs who had felt the very fashionable 'lure of the East', scientists too quickly began to take cameras with them on their travels.

Egypt was one of the lands most romanticized by the Victorian imagination; as early as July 1839 Arago had referred to the capacity of photography to 'make copies of the millions and millions of hieroglyphics' on Egyptian monuments. Soon the first photographers, like Itier, sailed up the Nile (see pp. 130–31) and took

daguerreotypes of the wonders of Ancient Egypt. They also explored the *terra incognita* of Africa. Others, including Itier, set sail for the Far East and photographed such places as Canton and Borneo. The versatility of photography made scientists of its practitioners, and many recorded not merely monuments but the peoples and fauna and flora of their remoter destinations.

The obstacles these pioneers faced cannot be overstated; to the risks run by explorers or missionaries were added the far from negligible professional risks and hardships of the photographer. The equipment was heavy and bulky and had to be accompanied by a large supply of daguerreotype plates, transported and no doubt little improved by carriage, boat, mule or camel. Under different climes exposure was unpredictable. Sensitizing and developing the plates in these conditions was an unenviable task; sand and dust threatened the plates, humidity damaged the camera, and chemicals, where they were available, were not reliable. The Muslim interdiction on the reproduction of the human form made photography such an object of suspicion to Islam that the Egyptian Khedive, on seeing a photograph for the first time, exclaimed, 'This is the work of the devil.' Elsewhere it was feared that the image of the body bestowed power over the soul, and that the soul, if not indeed the country as a whole, might be magicked away. The images that have survived are a testament to the courage and determination of their creators.

Their reports of their proceedings often make fascinating – and entertaining – reading. Charles DeForest Fredricks worked in a studio on Broadway before travelling with his daguerreotype equipment to Venezuela in 1843; here he made friends with an influential merchant by photographing the latter's dead son. He portrayed all

the notables of this town, earning a small fortune in the process, but then had to wait for new plates to be sent from America. While going up the Amazon, he had to survive for twenty-two days on manioc after Indians had absconded with his canoes and provisions. On his travels through the Rio Grande in 1844 he accepted payment in kind, one horse per photo, and at length sold an immense drove of horses for three dollars each. The governor of Corrientes paid for his portrait with a live tiger, but the animal's value was diminished by its death on the return journey to America.

Solomon N. Carvalho of South Carolina went as a photographer on an expedition across the Rocky Mountains in 1853–4. He described his experience thus:

To make daguerreotypes . . . in a temperature varying from freezing-point to thirty degrees below zero, requires a different manipulation from the processes by which pictures are made in a warm room . . . Buffing and coating plates, and mercurializing them, on the summit of the Rocky Mountains, standing at times up to one's middle in snow . . . I shall not appear egotistical if I say that I encountered many difficulties . . . a firm determination to succeed also aided me in producing results which, to my knowledge, have never been accomplished under similar circumstances.[19]

None of Carvalho's photographs of the expedition is extant. Another painter–photographer, John Mix Stanley, achieved the status of a great medicine man among the Red Indians. They worshipped the sun, whose favour Stanley clearly enjoyed, since he made use of it to produce astonishing likenesses of them.

For the European and American public, such photos of the unknown regions of the world were of unparalleled interest. Photographers became as celebrated as discoverers; their reports were eagerly awaited not only by the public but by governments.

Their images were featured in the international exhibitions of the 1850s, and photography was as acclaimed as 'sailing the oceans, conquering the mountains, crossing the continents'.

The end of the daguerreotype

The era of the daguerreotype was brief: it lasted from 1839 to about 1860. The manual *Sunlight Sketches* bade adieu to the process in 1858: 'O sad fate of the beautiful daguerreotype! I would to heaven I could forget it. But it lingers in my soul like the fond remembrance of a dear departed friend!'[20]

Photographic techniques have advanced to the point where it is easy and cheap for anyone in Western society to take photographs. But the beauty and clarity of the images from the earliest infancy of photography have meanwhile been forgotten. It is my hope that the pages that follow will return them to public attention in all their unique splendour.

Notes

1. M. Haworth-Booth, *The Golden Age of British Photography 1839–1900*, New York, Aperture, 1984, p. 22.
2. A. F. J. Claudet, 'Progress and Present State of the Daguerreotype Art', *Journal of the Franklin Institute*, 3rd series, no. 10, July 1845, p. 45.
3. G. Macdonald, *Camera: A Victorian Eyewitness*, London, Batsford, 1979, p. 22.
4. H. Gernsheim, *The Origins of Photography*, London, Thames and Hudson, 1982, p. 137.
5. B. Newhall, *The Daguerreotype in America*, New York, Dover, 1976, p. 77.
6. ibid., p. 76.
7. G. Gilbert, *Photography: The Early Years*, New York, Harper and Row, 1980, p. 10.
8. Newhall, op. cit., p. 57.
9. ibid., p. 96.
10. ibid., p. 97.
11. W. Crawford, *The Keepers of Light*, New York, Morgan and Morgan, 1979, p. 28.
12. ibid.
13. B. Bernard, 'Photodiscovery', *Sunday Times Magazine*, September 1978, p. 64.
14. Haworth-Booth, op. cit., p. 25.
15. Newhall, op. cit., p. 67.
16. N. Rosenblum, *A World History of Photography*, New York, Abbeville, 1984, p. 38.
17. Newhall, op. cit., p. 33.
18. Rosenblum, op. cit., p. 51.
19. Newhall, op. cit., p. 89.
20. ibid., p. 110.

The Photographs

All the following daguerreotypes are from the Richter Collection.

Measurements are given throughout in centimetres, width × height. Where 'plate' is cited, the plate itself was measured. Where it was not possible to extract the plate from the frame, the measurements of the 'inside frame' (the image as seen from outside through the glass) have been given; these do not necessarily correspond to the size of the plate or the image. The original measurement of the whole plate was 8·5 × 6·5 in (21·6 × 16·5 cm); the sixteenth plate is the smallest normally found. The image itself may be of any dimension smaller than the plate. Thus the size of the image is not necessarily that of the plate, and the inside frame measurements are not equivalent to either of these.

THIS STRIKING IMAGE of an English gentleman has a depth and dignity typical of the best early photographic portraits. The subject holds a book and a pear taken from the basket at the foot of his chair; he wears a jacket of unusual motif and a little red cap. It is the prosaic likeness of a dandy, either a wealthy and sophisticated landowner or a writer and poet. There is no clue to the gentleman's identity, and the photographer too remains anonymous, though he seems likely to have been provincial – a prominent London photographer would probably not have used the rustic chair seen here.

The image was discovered recently in Sussex. Its edges show the characteristic attractive discolorations produced by the oxidation of silver.

Anonymous
British
Seated gentleman holding pear
c. 1850
Inside frame 14·7 × 20·3 cm (full plate)

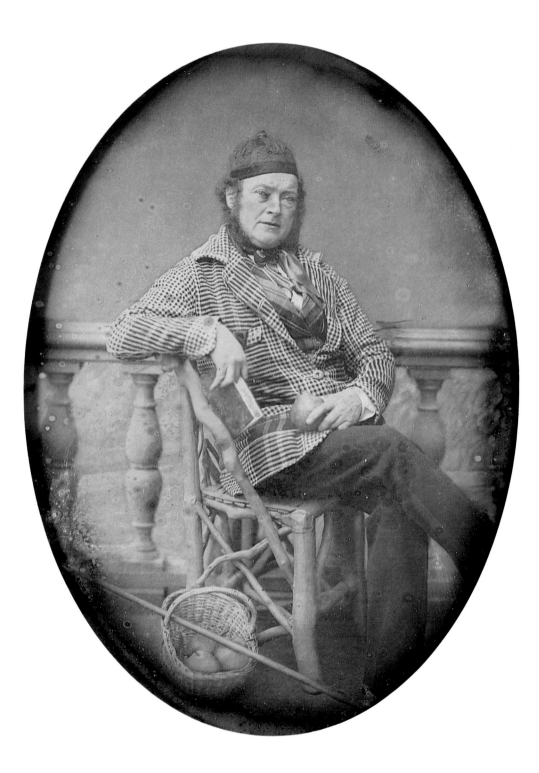

NOTHING IS KNOWN about Mrs Skinner, but her age in itself is food for thought. This daguerreotype is probably unique in showing a human being born around 1762, when George III had recently ascended the throne and the Anglo-French colonial wars were drawing to a close. Mozart was born less than ten years before Mrs Skinner; she was in her mid-twenties at the outbreak of the French Revolution, that is approaching middle age in terms of contemporary life expectancy.

Antoine François Jean Claudet
(1797–1867)
British, born France
Portrait of Mrs Skinner at ninety years of age
c. 1852
Plate 7·6 × 10·2 cm (quarter plate)

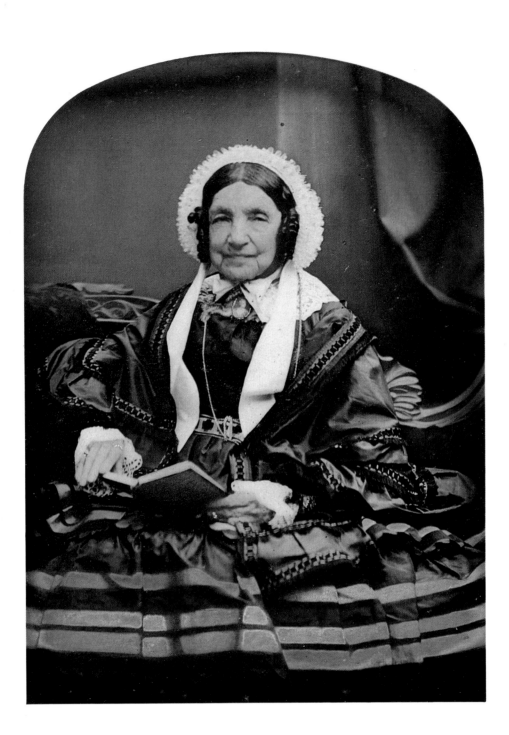

BRUDER WAS FROM THE Neuchâtel region of Switzerland. In this impressive daguerreotype a proud engineer poses beside a one-cylinder piston-driven machine, perhaps a compressor, with the maker's name, J. J. Gutknecht, on it.

Photography was no sooner invented than it was used to record other inventions. During the Industrial Revolution the European economic landscape was transformed, and the traditional energy sources – muscle power, wind and running water – were supplanted by coal-burning iron 'monsters'. Technological progress and improved communications contributed to the doubling of world trade between 1800 and 1850. It was the time of the great inventions. In 1814 George Stephenson invented the steam locomotive; three years later the German Karl Friedrich Drais von Sauerbronn invented the bicycle. Samuel Morse contributed the electromagnetic telegraph in 1837, only a few years after the invention of the electromagnetic engine by Moritz Hermann Jacobi in 1834. In Austria the first sewing machine was constructed in 1840, and in 1861 the German Philipp Reis devised the first telephone. In 1866 dynamite was invented by Alfred B. Nobel and the self-excited generator by Werner von Siemens.

Photography was the image-making tool of the Industrial Revolution. As a result of the partially mechanical process of photography, the equivalent of several days' labour on the part of the miniature painter could be produced in a matter of minutes.

C. H. Bruder
Swiss
Engineer with machine
7 August 1853
Plate 16·2 × 21·4 cm (full plate);
illustrated reversed

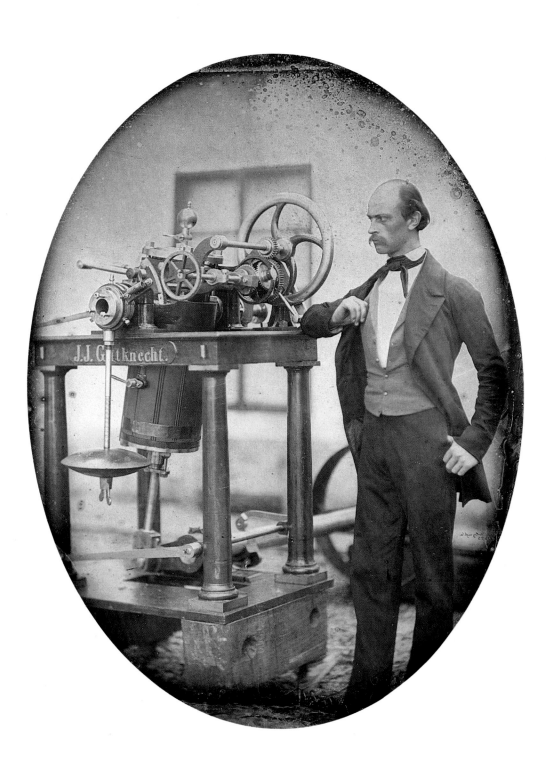

THIS STEREOSCOPIC STUDY by Claudet is most unusual in showing a very comprehensive selection of his laboratory instruments, artfully arranged in the manner of an allegorical still life. It was probably taken as a personal record. Claudet's reputation for ingenious composition is not belied even in this apparently informal shot.

The following items may be identified:

A a water-jacket (cooler and condenser for distillation)
B a telescope
C a focimeter (invented by Claudet in 1849), a folding aid to focusing; with achromatic lenses the visual focus did not coincide with the chemical focus
D apothecary's scales
E a globe (upside-down)
F the Post Office London Directory of 1852
G an array of chemical jars
H a (centrifugal force) speed controller
I a photographometer (invented by Claudet in 1848), an instrument used to gauge the sensitivity of photosensitive material, especially paper, and for measuring the intensity of light; this is the first light meter in photography
J a stereoscope with stereoscopic drawing
K a magnifying glass
L a slide rule
M a stereoscopic object (?)
N a large magnet (?)
O a stereoscope designed by Claudet for viewing stereoscopic daguerreotypes
P a glass prism
Q a stereoscope with paper stereograph
R a French treatise on photography
S⎱ two dynactinometers (invented by Claudet in 1850), devices for
T⎰ comparing the speed of different lenses
U mortar and pestle

Antoine François Jean Claudet (1797–1867)
British, born France
Laboratory instruments
1853
Plate 6·6 × 7·7 cm (half of a stereograph); illustrated reversed

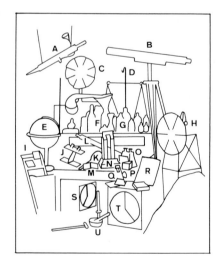

THE LONDON photographer William Kilburn made this impressive portrait in or around 1853. His subject is presented in profile, a feature unusual in early works of this kind. In 1846 Kilburn opened a studio – under licence from Beard – in Regent Street. He was a renowned portraitist, and his work is equal, if not indeed superior, to that of the better-known Claudet. He received a royal command to photograph the royal family in 1847, and was awarded a prize medal in the 1851 Great Exhibition at the Crystal Palace.

Nicholas Patrick Stephen Wiseman (1802–65) was professor of oriental languages at the University of Rome and curator of Arabic manuscripts at the Vatican Library under Pope Leo XII. In 1840 he was consecrated Bishop and sent to England, where the Vatican gave him responsibility for the churches of the central district. When, in 1850, Pope Pius IX began to restore a diocesan hierarchy in England, he created Wiseman Cardinal and appointed him the first Archbishop of Westminster. Wiseman bore a considerable role in the upsurge of Catholicism in Great Britain at this time. He was an energetic social reformer, and one of the most learned men of his time.

William Edward Kilburn (active 1846–64)
British
Portrait of Cardinal Wiseman
c. 1853
Inside frame 6·6 × 9 cm (quarter plate)

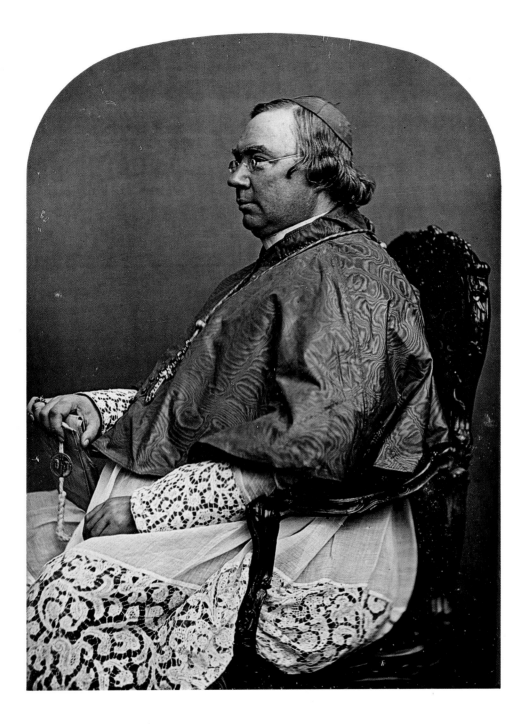

SAMUEL TOPHAM, an ex-engraver, decided that a photographic studio in Leeds, which was then a thriving industrial centre, was bound to prosper. He and his partner purchased a licence from Richard Beard giving them exclusive rights to photographic custom in Leeds. It cost them 'a heavy sum', probably around two thousand five hundred pounds. In spring 1842 their Photographic Portrait Gallery opened at 27 Park Row. Topham was the senior financial partner, but the photos were taken by William Huggon. Here the Mayor of Leeds for the year 1849/50, Joseph Bateson (d. 1867), poses for Huggon in full regalia and with rather ferocious dignity.

William Huggon (active 1842–80)
British
Portrait of Joseph Bateson, Mayor of Leeds
1849
Plate 7·5 × 10·1 cm (quarter plate)

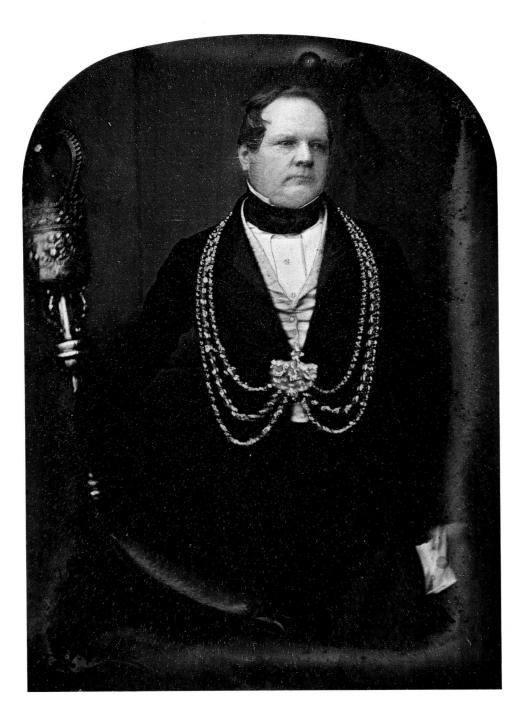

THIS SUBTLY TINTED and brilliantly contrived portrait, composed against a painted cloudscape that is juxtaposed with the vivid chinoiserie of the fan, creates a strongly symmetrical impression. The sitter has been able to maintain her amiable dignity despite the length of exposure necessary.

Anonymous
British (?)
Lady with fan
c. 1850
Inside frame 6·5 × 8·8 cm (quarter plate)

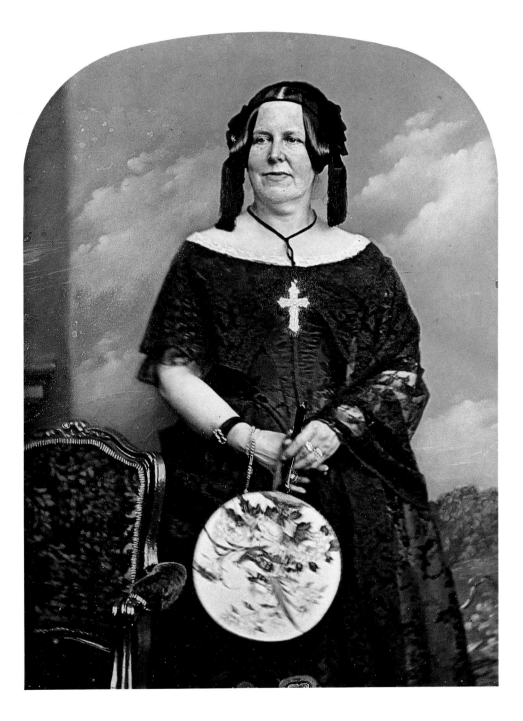

THIS IMMACULATE and beautifully hand-tinted daguerreotype shows a distinguished-looking British officer in mess dress, possibly that of the 1st Dragoons. Distinctions of rank did not appear on the mess jacket until 1856, so we have no clue as to the sitter's identity. Claudet was the first British photographer to introduce painted backgrounds, and the example here is particularly elaborate.

Antoine François Jean Claudet
(1797–1867)
British, born France
Officer in mess dress
c. 1853
Plate 12 × 16 cm (slightly larger than half plate)

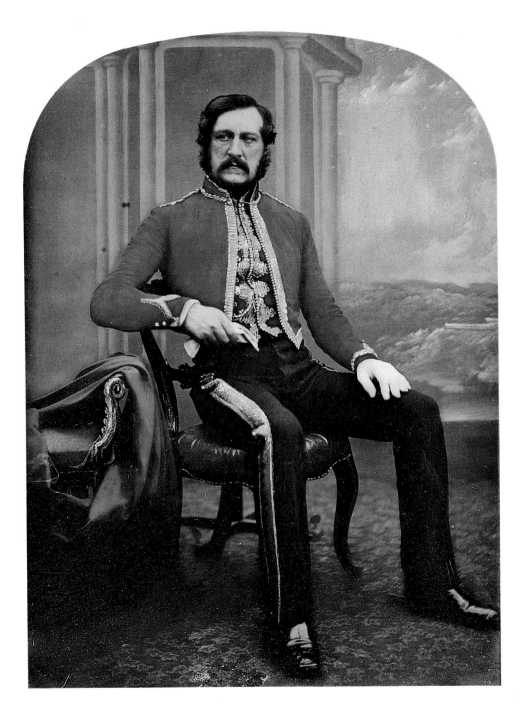

THIS PORTRAIT OF AN Austrian colonel or general was taken by the itinerant photographer Béguin, who was of French origin and changed his first name to Enrico.

The impeccably lit sitter is swathed in the massive drapery of his cloak, which leads the eye back from the intricate lines of the foreground to his head. The officer's confident air is not entirely borne out by the nervous glint in his eyes. The portrait is of remarkable simplicity and timeless power, and it loses nothing even in comparison with the acknowledged masters of portraiture, Southworth and Hawes. A characteristic of the best-quality plates of the time may be seen in the bottom left-hand corner of the plate: the hallmark of the (French) plate manufacturer.

Enrico Béguin
Italian, born France
Portrait of an Austrian colonel or general
c. 1850
Plate 12 × 16 cm (larger than half plate)

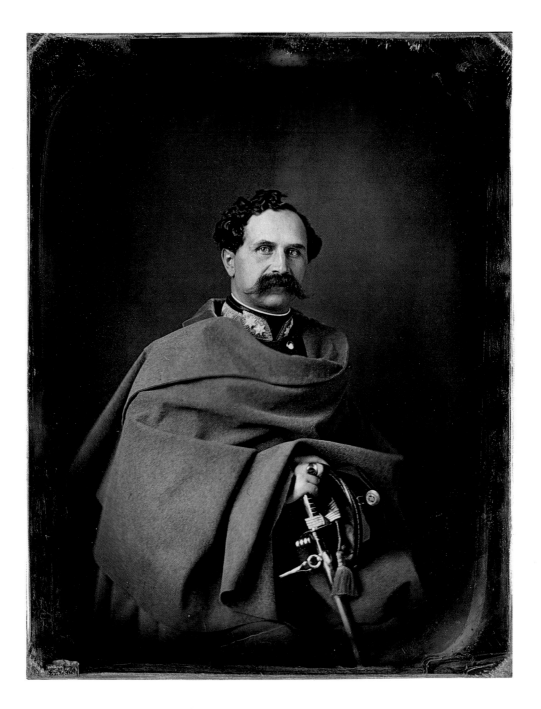

IT IS RARE TO FIND relaxed and pleasant expressions in daguerreotype portraits, as the lengthy exposure eliminated all spontaneity. During the early years the sitting retained an aspect of intimidating ceremony, which was often reinforced by a certain apprehension on the part of the sitters when faced with the instruments of an unfamiliar technology. But occasionally the skills of the photographer triumphed, and the result was such as this vivid and informal picture taken by the Stockholm photographer Beurling on a visit to Havana. The effect is scarcely more inhibited than the family snapshot of today.

G. F. Beurling
Swedish
Group portrait of a Cuban family
24 February 1855
Plate 16 × 14·1 cm (two-thirds plate)

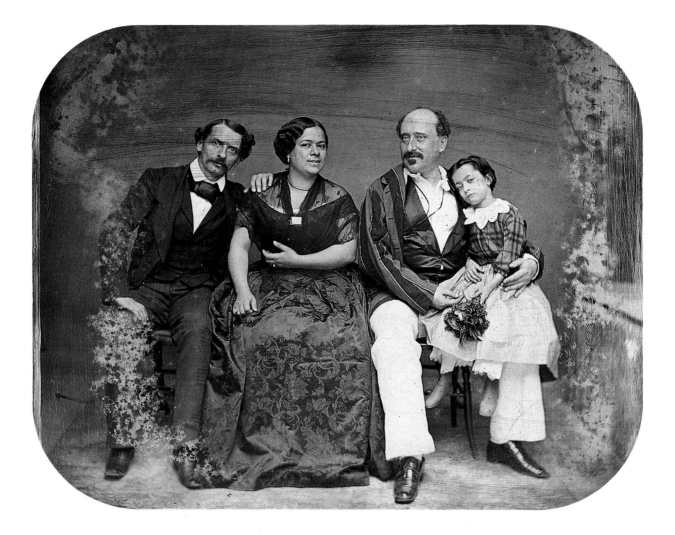

IN OR AROUND 1845 the German cabinet-maker Trudpert Schneider from Ehrenstetten met the itinerant daguerreotypist Broglie, who taught him the daguerreotype process. Schneider quickly surpassed his teacher and with his two sons, Wilhelm and Heinrich, began his own career as a travelling photographer. They took many stereographs, in particular of the aristocracy, and word of their excellence as portraitists spread. In 1858 Trudpert grew tired of life on the road, but his sons continued their travels and worked in Hamburg and Berlin, where Prince Friedrich Wilhelm was among their sitters. In 1861 they travelled to Moscow; a recommendation from the Grand Duke of Baden gave them an entrée to photograph the Russian nobility.

After returning to Germany, they founded a studio and photographic firm in Krozingen in 1867. They won innumerable medals and awards for photography. In the 1920s many of these stereographs were still in the possession of the photographers' descendants, but they have mostly since been lost or destroyed. The Schneider brothers continued to use the daguerreotype process until 1860, long after most European photographers had turned to the collodion process.

This frumpish couple have been at great pains to perfect their costume and are correspondingly conscious of their dignity. The woman has been 'perched' on a level with her husband, who stands. The different angles of the two lenses are clearly visible, notably in the greater expanse of cheek presented by the woman in the right-hand picture.

Trudpert Schneider (1804–99) and Sons
German
Portrait of a couple in Tyrolese peasant costume
c. 1858
Plate 11 × 7·7 cm (stereograph)

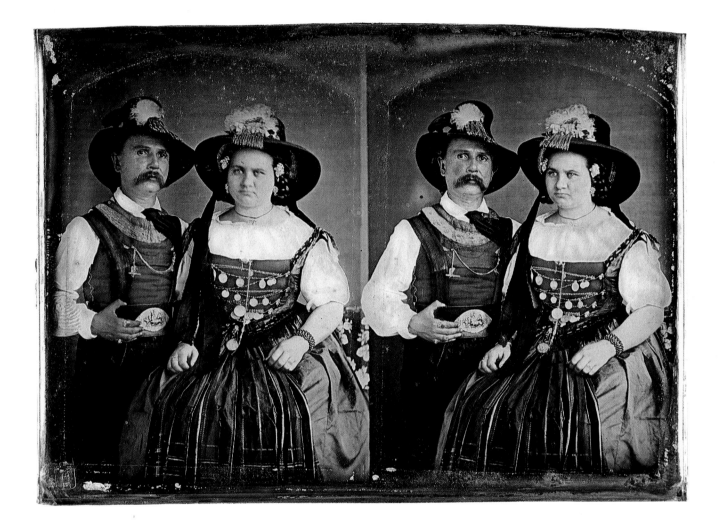

THE ABSENCE OF props and the very direct and frontal image suggest that this is the work of an itinerant daguerreotypist operating without the facilities of a studio. This impression is reinforced by the tension apparent in the sitter, who seems, to judge by his expression, somewhat unfamiliar with the medium. The lack of studio trappings in no way detracts from the expressive power of this simple, four-square portrait.

Anonymous
German
Seated man with umbrella and top hat
c. 1845
Inside frame 5·8 × 7·1 cm (quarter plate)

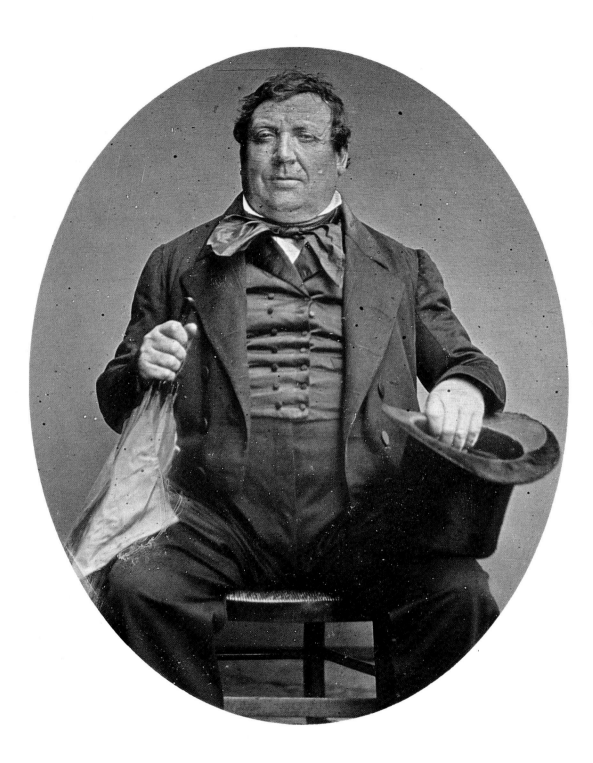

THE SITTER IN THIS straightforward but impressive portrait seems to feel an apprehension of the camera paralleled by that of the German sitter in the plate facing p. 42. If this elderly woman worked in the household of a southerner, she was almost certainly a slave. It was not until the advent of cheaper processes, such as the tintype, that the poor could afford their own portraits, so images of this kind are extremely rare.

Anonymous
American
Portrait of a black woman
c. 1850
Plate 6·9 × 8·2 cm (sixth plate)

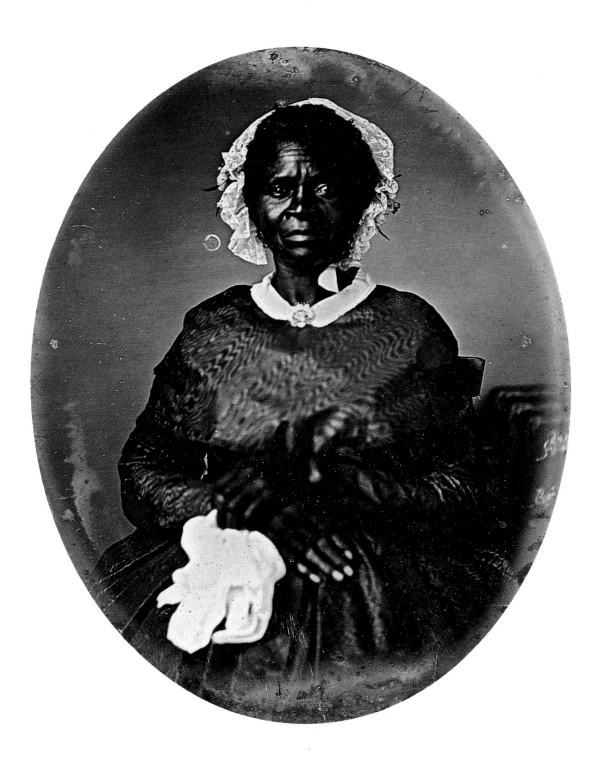

FEW DAGUERREOTYPES of slaves or ex-slaves exist, with the exception of those taken for pro-slavery propaganda. The provenance of these portraits is significant. They come from the Quaker state of Pennsylvania, founded by William Penn in 1681, where, towards the middle of the eighteenth century, the Quakers spontaneously freed their slaves and began agitating for the abolition of slavery. The inscription on the back of the portrait of the man mistakenly places Carbondale in (nearby) 'Luzerne County', and both were recently found near Luzern in Switzerland. Were they perhaps brought back by relatives of Swiss settlers?

It seems likely that the two were man and wife. The portrait of the woman has been handled outside its case, and the ensuing damage is all too visible. The portrait of the man, however, is in perfect condition. It is an absolute classic of American daguerreotype portraiture: profound, dramatic and intense. The sidelighting enhances the nobility of the features.

Emancipation came in America with Lincoln's proclamation in 1863; by 1861 the daguerreotype was outmoded. Even in its last years the process was too expensive for the poor. The conjunction of subject and process here is therefore of the utmost rarity, to which must be added the superlative artistry of the portraits. They were presumably made for the head of a household where both worked.

Anonymous
American
Portraits of a black man and woman from Carbondale, Pennsylvania
c. 1850
Inside frames 6·6 × 9 cm (quarter plates)

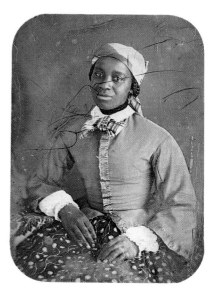

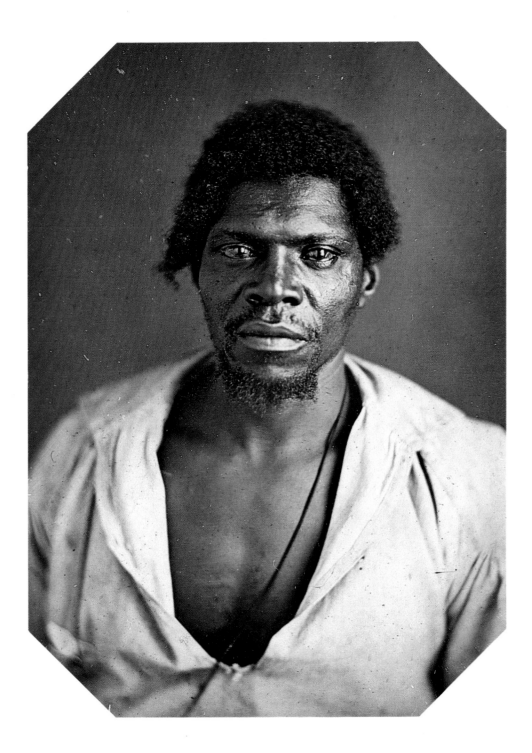

THESE FINE HAND-TINTED portraits of Henry Mason and his first wife, Fanny, clearly illustrate why the painted miniature portrait was suddenly eclipsed. They were taken by Richard Beard, a coal merchant who became interested in photography; in 1841, after hearing of the success of the first New York studio, he opened the first photographic portrait studio in England. He spent seven thousand pounds on the patent for Wolcott's camera, and a mere eight hundred pounds on Daguerre's patent for England, Wales and the colonies. Although he made a fortune from his studio and opened others, his means were eroded by the litigation he entered into in defence of his monopoly; in 1849 he went bankrupt.

George Cruikshank celebrated the first British studio in the following lines:

Your image reversed will minutely appear
So delicate, forcible, brilliant and clear
So small, full, and round, with a life so profound
As none ever wore
In a mirror before.

Richard Beard (1802–88)
British
Portraits of Fanny and Henry Mason
c. 1852
Plates 7·5 × 10 cm (quarter plates)

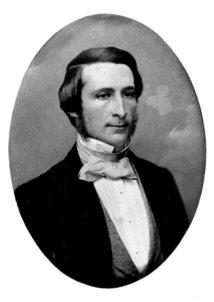

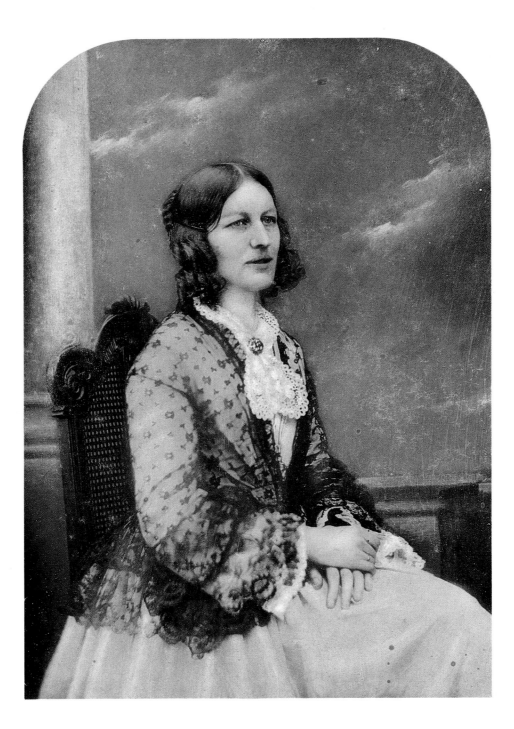

THIS SPLENDID PORTRAIT shows a Scotsman wearing full Highland dress. His plaid is worn over his left shoulder and held by a large brooch with a cairngorm in its centre. A broad belt with a large buckle is at his waist, and he is wearing a sporran, traditionally made of badger hide, with a silver top and silver-headed black tassels. On his head sits a bonnet with tartan headband, black ribbon rosette and a silver thistle brooch. His kilt and his plaid are of two different tartans; the tinting is not detailed enough for them to be identified.

Anonymous
Probably Scottish
Scotsman in Highland dress
c. 1850
Plate 7·6 × 10·1 cm (quarter plate)

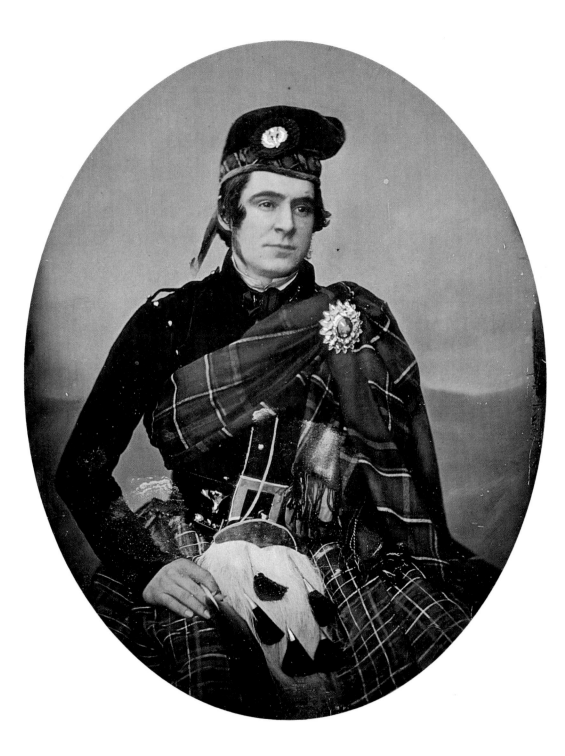

BARON HUMBERT de Molard was a keen amateur photographer who specialized in genre photographs. The scene shown here is reminiscent of the works of the later pictorialist school of photographers. Its popular and apparently spontaneous grouping was achieved by a careful posing of the characters such as occurred in more formal group portraits. This masterpiece was taken at the Baron's country estate at Argentelle in Calvados, and two of his models were his son Gabriel (*right*) and the manager of his estate, Louis Dodier (*seated left*). The woman wears the tall coif of the local costume of Lisieux.

Humbert de Molard learnt photography from one of its pioneers, Hippolyte Bayard, in 1840. He quickly established his own style, characterized by elegant and complex compositions such as this.

Baron Louis-Adolphe Humbert de Molard (1800–74)
French
'The Card Players'
c. 1845
Inside frame 12·7 × 9·7 cm
(approximately half plate)

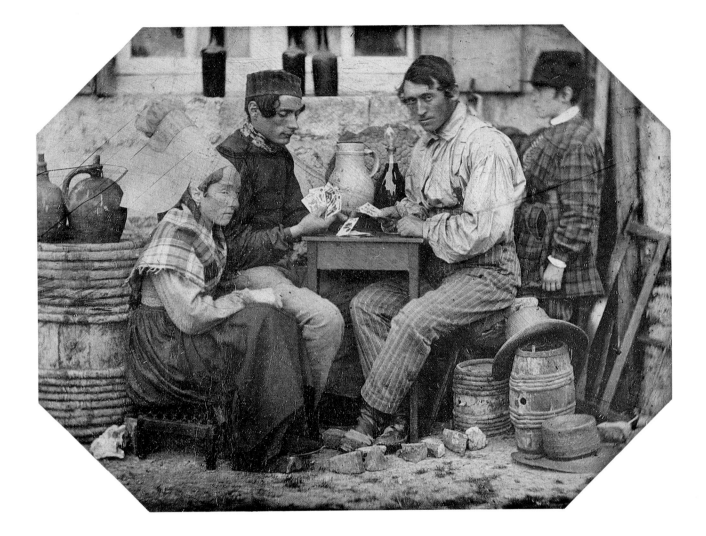

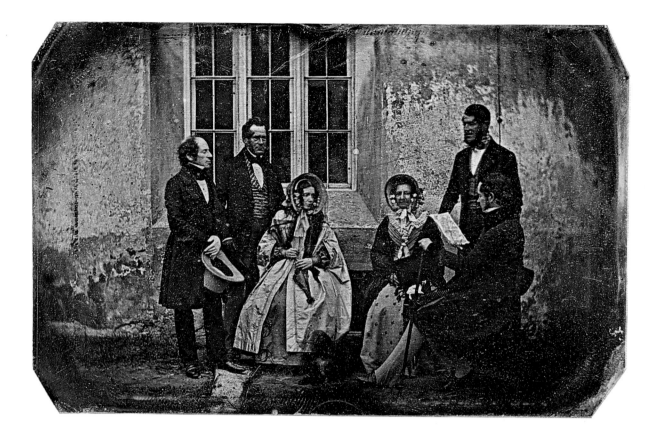

THESE TWO OUTDOOR daguerreotypes may have been for private purposes or may perhaps record the activities of a society; they seem to be neither genre photographs nor group portraits. One at least of the subjects appears in both images.

Anonymous
American (?)
'The Letter'
c. 1847
Plate 8·3 × 5·5 cm (eighth plate)
'The Card Players'
c. 1847
Plate 7·3 × 5·5 cm (ninth plate)

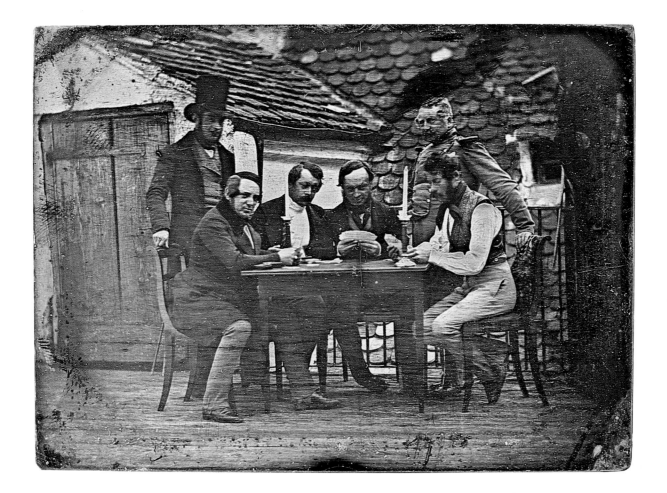

THE GROUP PORTRAITS taken by Claudet in his London studio at 107 Regent Street rank among the finest daguerreotypes for their skilfully crafted composition. Claudet staged domestic interior scenes with impeccable taste, and the groups are always artfully arranged. His care may be attributed to his less than sanguine outlook; the daguerreotype process, he said, was so difficult that 'failure is the rule and success the exception'. Claudet was regarded as the great master of stereoscopic photography.

The studios of the time were glazed with blue-tinted glass to reduce the temperature while maximizing the proportion of chemically active wavelengths. Glasshouse Street, just off Regent Street, owes its name to the glasshouses built as photographic studios, mostly on the roofs of existing buildings, around Piccadilly and Regent Street.

Antoine François Jean Claudet
(1797–1867)
British, born France
The Chess Players
c. 1853
Inside frame 5·9 × 6·8 cm (half of a stereograph)

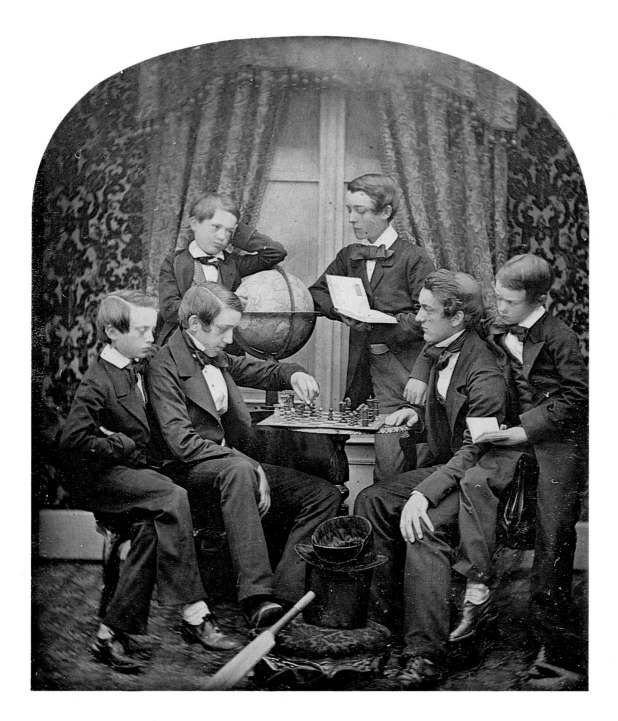

THE PROVINCIAL photographer who made this sensitive portrait of two young sisters also portrayed their father (see plate facing p. 20). The girls' frank, level gaze gives the image unusual authority. The photographer's directness of approach was exceptional for its time, and might on stylistic grounds date from the beginning of the twentieth century.

Anonymous
British
Portrait of two young ladies
c. 1850
Inside frame 10·5 × 14·5 cm (half plate)

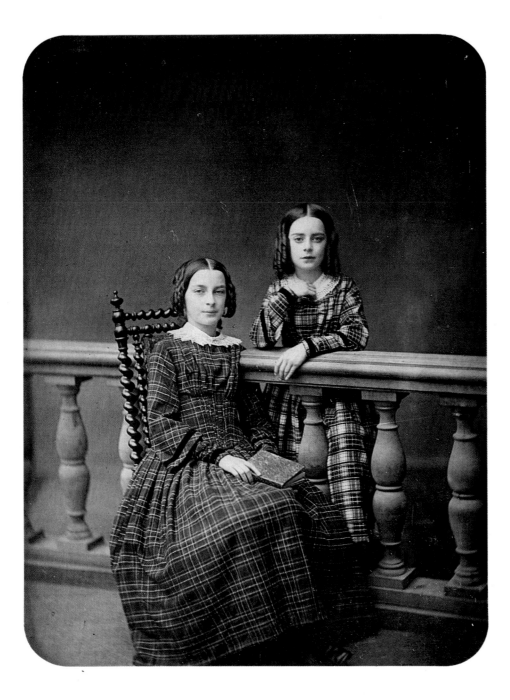

IN AN UNUSUAL collocation, two different kinds of photograph – a daguerreotype and an ambrotype – are contained here within a single ornate brass frame.

In 1851 Frederick Scott Archer invented the collodion process, which allowed many positive paper prints to be made from a single glass negative. This advantage was decisive, and the method quickly replaced the daguerreotype. When a collodion glass negative was placed on a dark background, it could be viewed as a positive, so the back of the glass plate was sometimes painted black for this effect; the resulting image was called an ambrotype.

This British lady had her daguerreotype portrait taken around 1850, and some six years later had a further portrait made by the collodion process, this time with her daughter. The two images were subsequently framed together.

Anonymous
British
Lady showing fashion plate
Daguerreotype
c. 1850
Mother with her child
Ambrotype
c. 1856
Inside frames 4·9 × 7 cm (eighth plates)

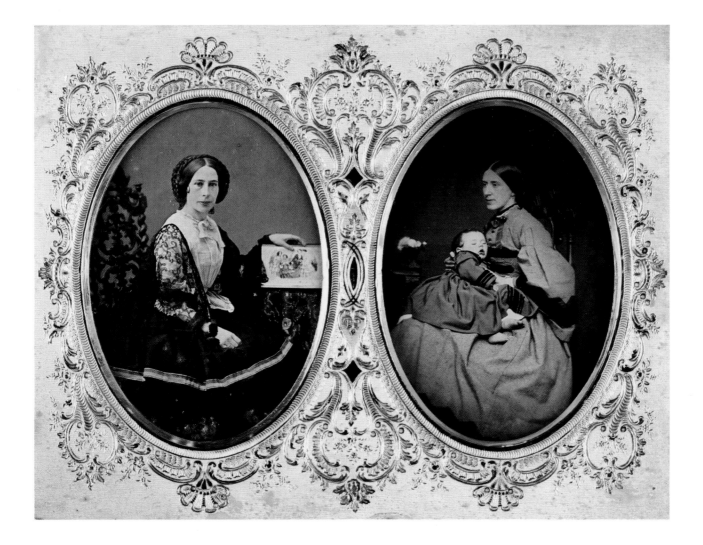

THE NATURAL RESTLESSNESS of children did not prevent this photographer from obtaining an excellent group portrait. The dress and toys suggest that the photo is American in origin.

Anonymous
British or American
Woman with ten children
c. 1850
Inside frame 7·6 × 6·4 cm (sixth plate)

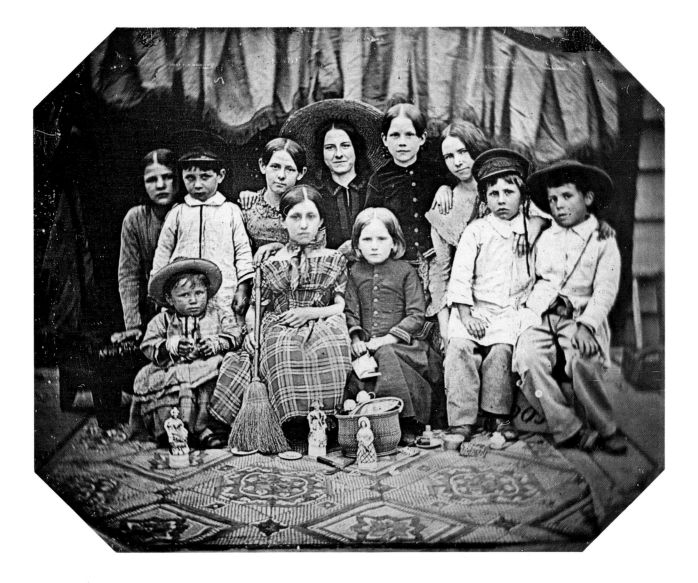

IN THIS AMUSING portrait a parental hand emerges from the penumbra and firmly holds the child's head still. Children were always difficult to photograph, as they would seldom sit absolutely motionless for the required period; this was sometimes made the excuse for a supplementary charge by the photographer. Even for adults, free-standing headrests were required to clamp the head in position. The expression 'watch the birdie' is thought to have originated around 1855 in a New York studio where 'a little toy bird singing on the camera' was used to capture the child's attention.

Anonymous
British
Portrait of a young girl
c. 1850
Plate 7 × 8 cm (sixth plate)

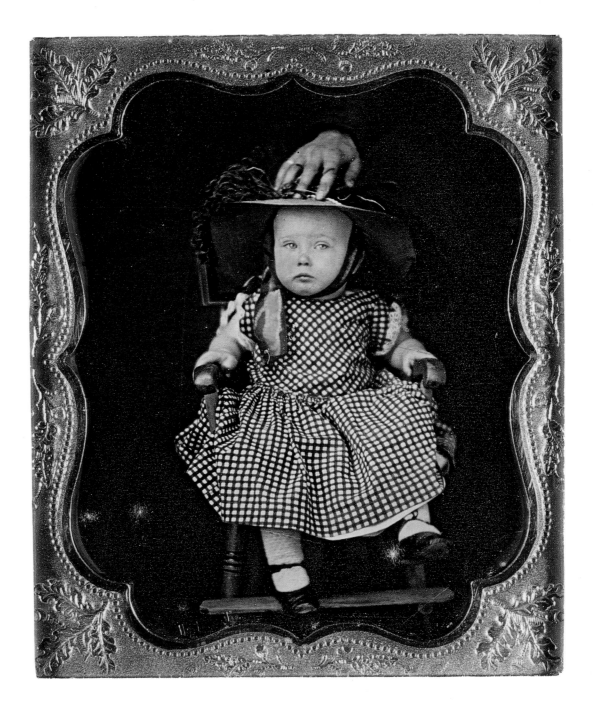

WILLIAMS IS BEST KNOWN today for the interior views of the Crystal Palace attributed to him (see plate facing p. 122), but he was also a master of genre subjects and still life. His portraits of children, which are perfectly composed down to the minutest detail, are superb. The definition of the boy's jacket in this example is impressive, and it suggests that the lens was of exceptionally high quality for the time.

One of Claudet's first assistants, Williams was recognized as a most skilful and gifted photographer soon after the opening of his own studio at 236 Regent Street in 1855.

Thomas Richard Williams
(1825–71)
British
Portrait of a young boy
c. 1855
Inside frame 5·6 × 6·8 cm (half of a stereograph)

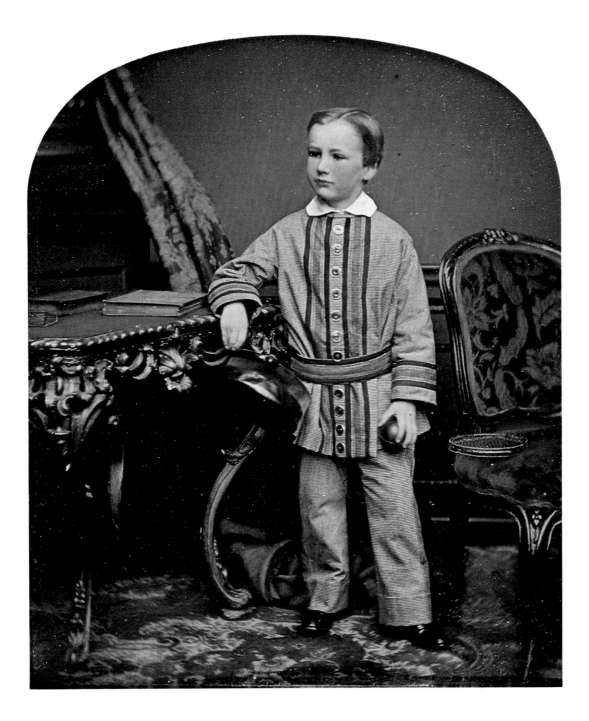

THE ELABORATE PAINTED landscape background and cunningly contrived light source combine to moving effect in this unusual picture. The woman's costume, the sentimental subject and the artifice of pastoral seem to derive from religious painting. The baby, whose immobility could not be guaranteed, is invisible, and may indeed be altogether absent.

Anonymous
French (?)
Mother with her baby
c. 1850
Plate 12·1 × 16·2 cm (larger than half plate)

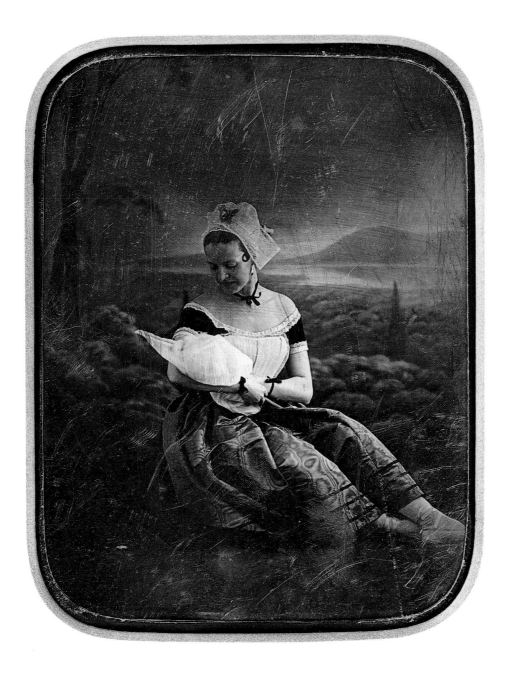

THIS IS A TYPICAL group portrait from Claudet's Regent Street studio. The draped window and richly ornamented wallpaper may be seen in many of his stereoscopic portraits.

Born in Lyons, Claudet began his career in banking, then worked for a glass company. After his marriage to an English girl, he moved to London in 1827 to represent the company there. In 1839 he went to Paris to study photography under Daguerre himself. He paid the patent agent two hundred pounds for a licence to operate in London, and in 1841 he opened a studio on the roof of the Royal Adelaide Gallery at 18 King William Street. His portraits quickly made him famous. In 1842 he took views from the top of the Duke of York's Column, which were reproduced as engravings in the *Illustrated London News*.

Claudet was also a prolific contributor to the technical side of photography; he succeeded in reducing exposure times and invented the dark-room light and a sort of light meter. He opened his Regent Street studio in 1851 and received royal patronage two years later. In 1865 he was made *Chevalier* of the *Légion d'honneur*.

Antoine François Jean Claudet
(1797–1867)
British, born France
Mother and three daughters
c. 1853
Inside frame 5·7 × 6·8 cm (half of a stereograph)

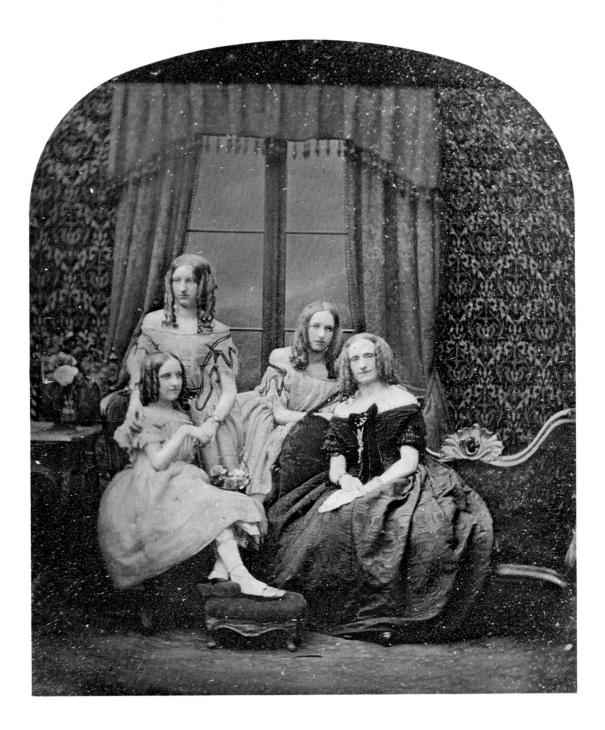

THE DARING OF this image lies in the combination of the plunging angle and neckline and the enticing suggestiveness of the woman's expression. It is a *risqué* portrait, of a kind that could be openly sold but was none the less explicit in its invitation.

Anonymous
French
Woman in low-cut dress
c. 1855
Inside frame 5·5 × 6·4 cm (half of a stereograph)

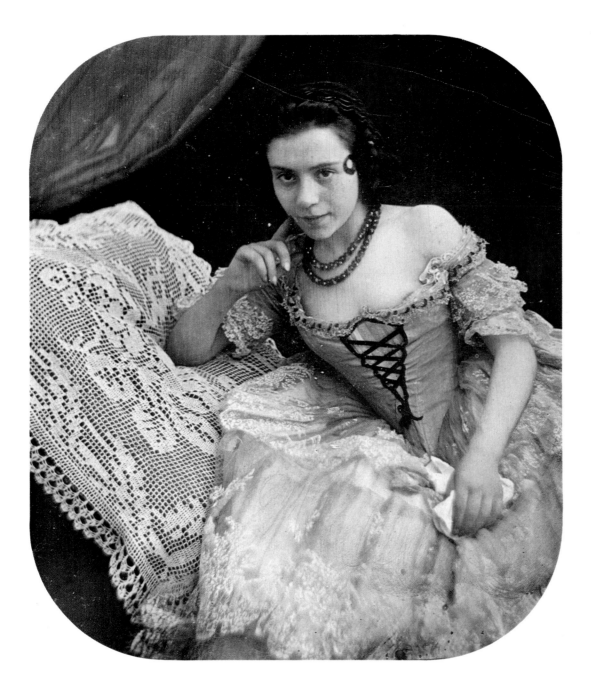

THE STRIKINGLY FRANK and relaxed expression of the model gives the impression of a personal encounter with this confident young woman of the 1850s. At a time when spontaneity was often quite lacking in portraiture, the informality and directness of the pose are all the more remarkable. Careless handling has damaged the photograph without impairing its exceptional charm.

Anonymous
French
Nude woman with cushion
c. 1855
Inside frame 5·9 × 6·7 cm (half of a stereograph)

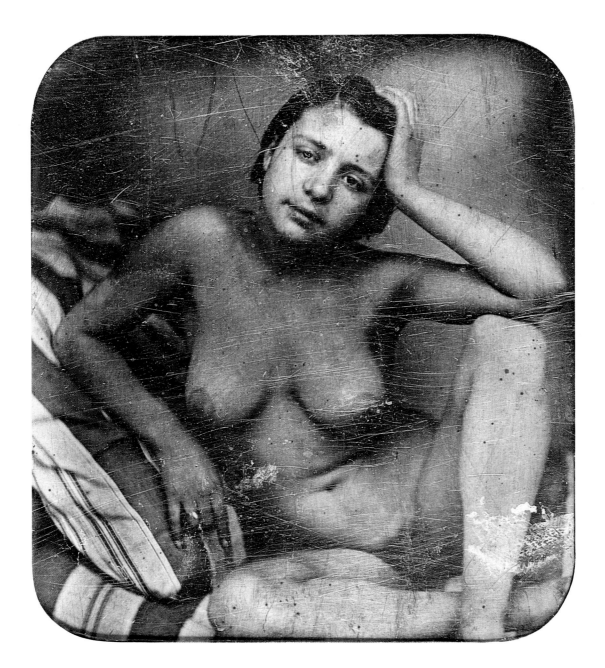

THIS STUDY WAS probably made by or for a French sculptor or painter. Male nude daguerreotypes are extremely rare as there was little or no commercial incentive to produce them, but nevertheless female and male studies had a considerable impact on contemporary painters. Delacroix stated that a painter who made the right use of daguerreotypes might 'raise himself to heights we do not yet know', and commissioned Durieu to make studies of poses and compositions under his supervision. He painted his 'Odalisque' directly from a daguerreotype. The influence of photography has also been perceived in Ingres's compositions, though in his case no acknowledgement was forthcoming.

Anonymous
French
Male nude study
c. 1843
Plate 5·6 × 7·3 cm (eighth plate)

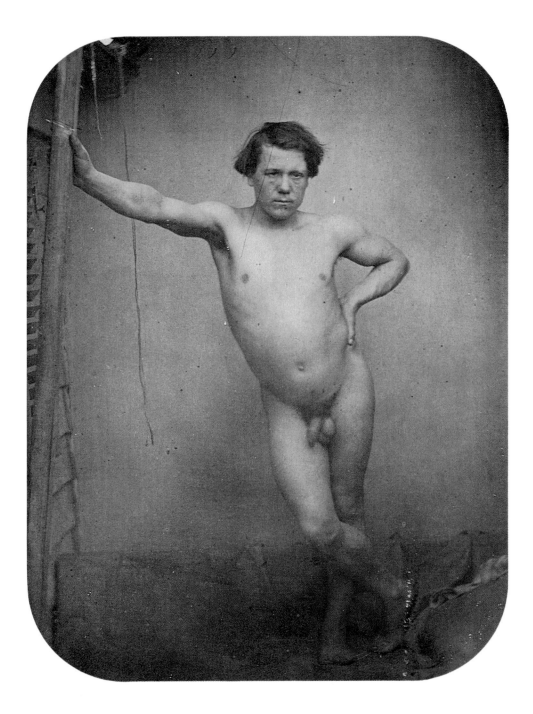

THIS NUDE STUDY is by the same photographer as the preceding male nude. Very few nudes were taken in the 1840s, and genuine studies on daguerreotype are in any case rare. They allowed the artist to examine at length a pose that could not be held by the model for long, and represented a considerable saving for the artist. In 1850 a model was paid four francs for a four-hour session; beautiful Jewesses were more sought after and were paid six francs. (This was substantially higher than the daily wage of a female domestic servant.) The sobriety and discretion of the pose confer a classical yet touchingly personal authority on this picture.

Anonymous
French
Female nude study
c. 1843
Plate 5·6 × 7·3 cm (eighth plate)

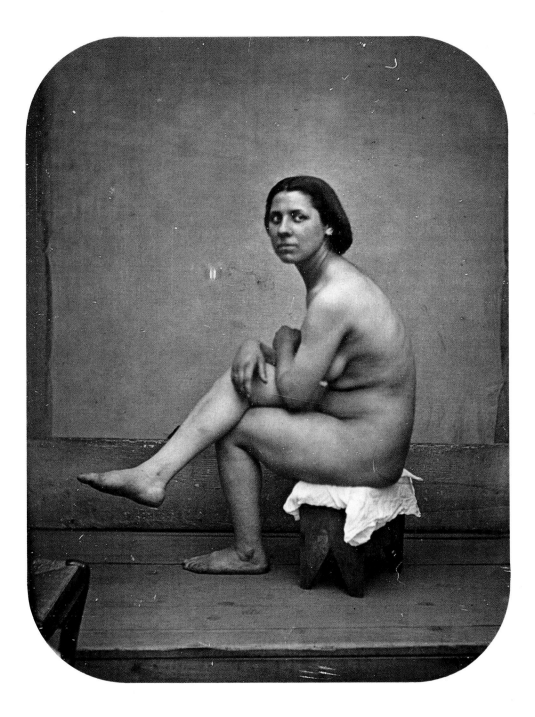

THIS IS PROBABLY an authentic nude study, but it shows signs of a transition between the study and overtly erotic genres. The accessories, for example, are not normally found in the former. The column is more than a claim upon the reverence felt towards classical art: it allowed the model to remain still for the duration of the exposure. The classical bric-à-brac is peculiarly unconvincing, and may derive from the neo-classicizing painting of the 1830s.

Anonymous
French
Nude woman with column
c. 1847
Plate 6 × 7·5 cm (eighth plate)

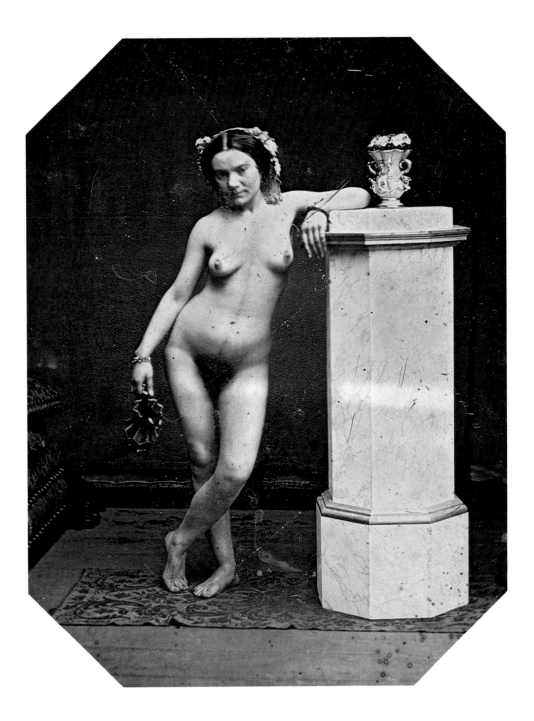

THE DÉCOR HERE is that of a boudoir. Although the woman's shape is exaggerated by her posture, one might be forgiven for thinking she was pregnant, which would be most unusual in a photograph of this kind. It is notable that the mirror is not used to expose her body further. The composition is characteristic of painting and has a Pre-Raphaelite elegance.

It seems likely that this is one half of a stereograph; the case is almost certainly British or American, and is definitely not original.

Anonymous
French
Nude woman in front of mirror
c. 1855
Plate 6·2 × 7·8 cm (probably half of a stereograph)

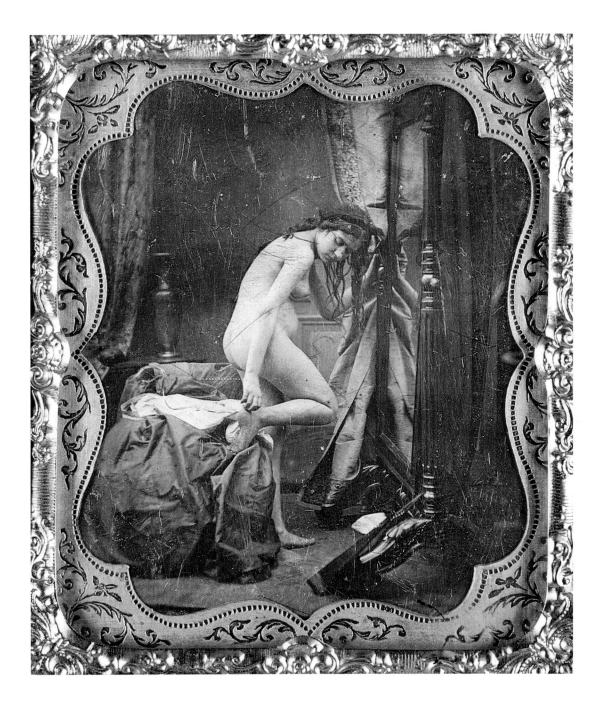

THE CONFIDENT STARE of the model and her sinuously reclined position both derive from the conventions of painted erotica, as does the gesture of touching her breast in an invitation to the viewer to do the same. Her pose is admirably contrasted with the right angles of the fabric of the divan. Such daguerreotypes were not difficult to acquire and sustained Paris's legendary status as the sexual capital of the West.

Anonymous
French
Reclining nude on chaise-longue
c. 1855
Inside frame 5·4 × 6·5 cm (half of a stereograph)

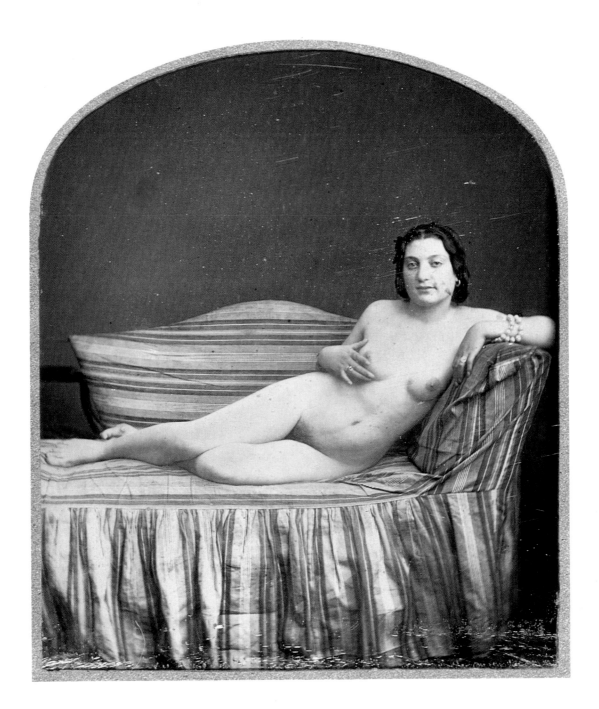

MELANCHOLY SPEAKS in this woman's eyes. The jewellery she apparently wears is in fact gold paint added directly to the plate. The traces of oxidation on the plate and the dust that has collected between the image and its glass give instant nostalgia value to this image of some 130 years ago.

Anonymous
French
Nude woman seated at table
c. 1855
Inside frame 5·6 × 6·4 cm (half of a stereograph)

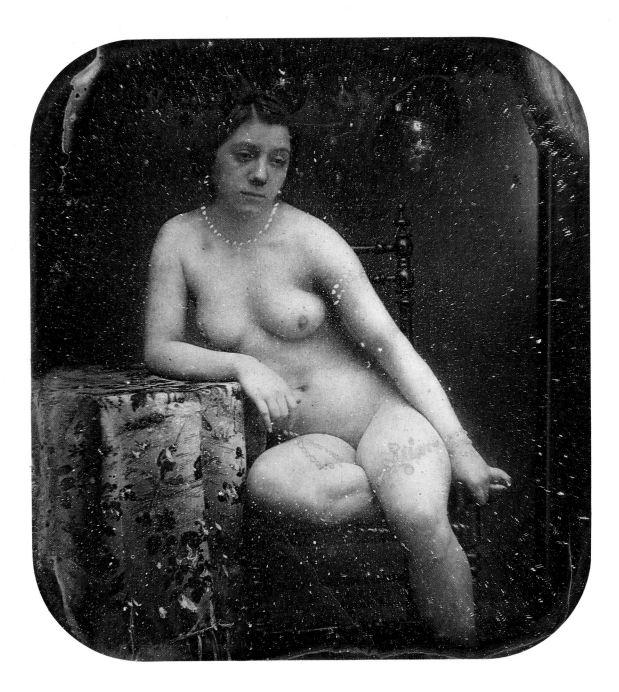

THE SUBJECT SEEMS in little doubt as to the effect she is likely to have on the viewer. She may not have expected that it would long survive not merely her youth but her entire epoch.

The cost of an erotic stereograph was some twenty francs for a tinted plate, and more for explicit scenes; the average daily wage of a worker in the 1850s was about three francs. The daguerreotype remained, at least in Europe, very largely the preserve of the middle and upper classes.

Anonymous
French
Nude woman with veil on divan
c. 1855
Inside frame 5·9 × 6·7 cm (half of a stereograph)

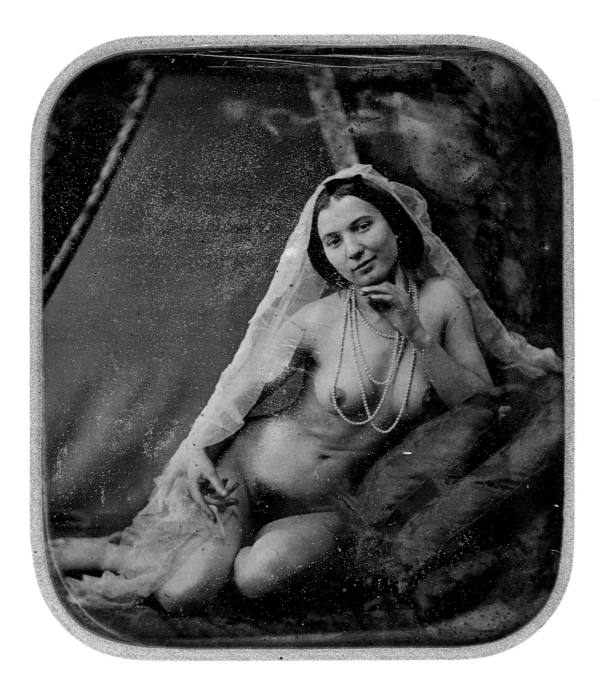

THE EARLIEST daguerreotype nudes, none of which survives, are attributed to Lerebours, and subsequent works were mostly anonymous. Although the advent of the stereoscope caused an upsurge in the production of daguerreotype erotica, they remained a luxury item. This was one area in which the collodion process did not entirely supplant the daguerreotype, and daguerreotype stereograph nudes were made until quite late in the century.

Here the graphic strength of the nude pose is enhanced by the swirl of drapery. Time has transcended the commercial motive and added a new depth; the beauty of the body has far outlived the young model, and in the image we are greeted with the simple and poignant fact of death.

Anonymous
French
Reclining nude with red drapery
c. 1855
Inside frame 5·6 × 6·6 cm (half of a stereograph)

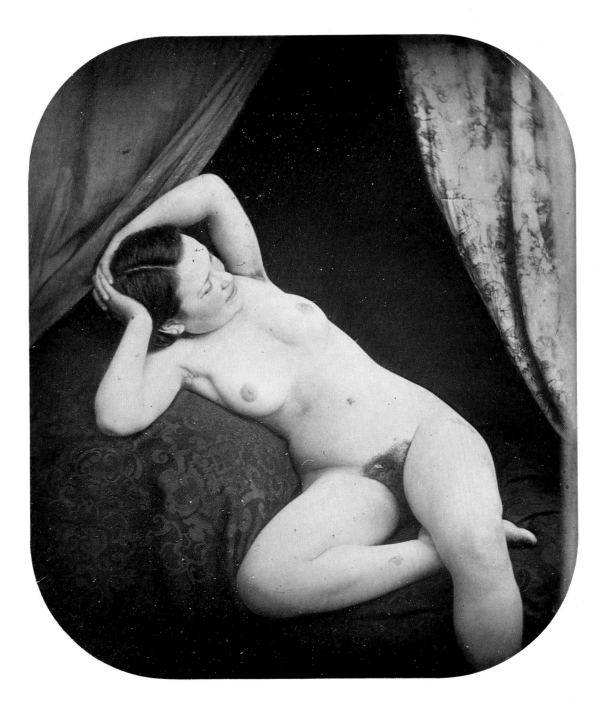

THE SAME MODELS appear again and again in daguerreotype nudes. This face is a familiar one, as a comparison with the study facing p. 74 shows. The studios that specialized in erotic photography would regularly use a 'stable' of some five or so professional models.

Anonymous
French
Reclining nude
c. 1855
Plate 6·9 × 7·4 cm (probably half a stereograph)

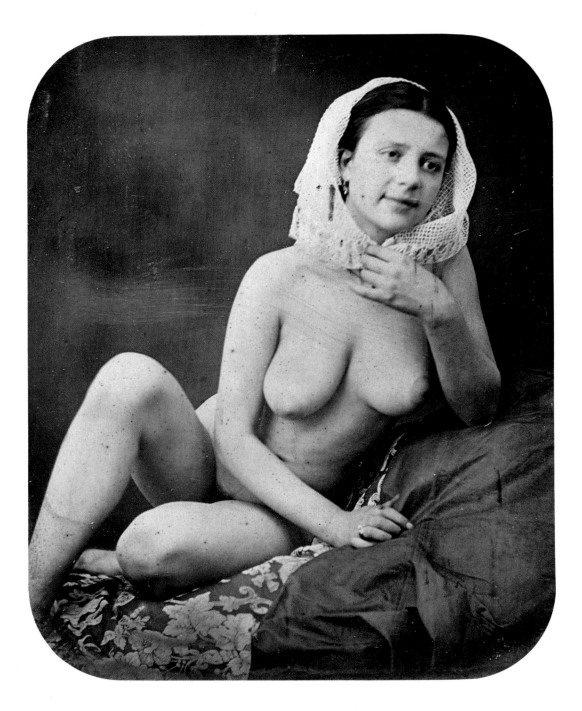

THE CHARM OF THIS erotic genre piece is not diminished by our knowledge that the bird is stuffed; the extended exposure did not allow the use of a live bird. The plate is superlatively hand-tinted, and the colours are extremely realistic. Parisian studios had a considerable export market for such pictures, and their products were distributed throughout Europe.

Anonymous
French
Nude woman holding bird
c. 1855
Inside frame 5·9 × 6·6 cm (half of a stereograph)

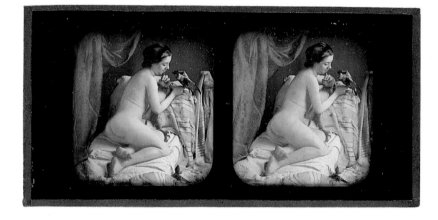

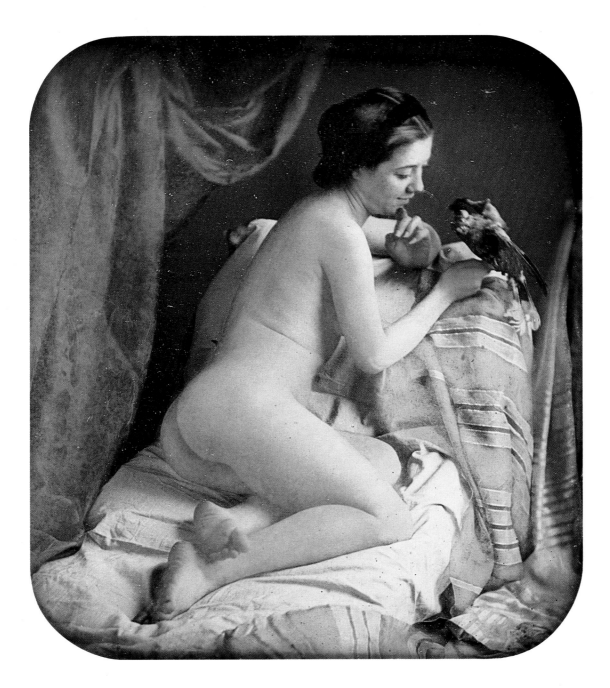

EVERY EPOCH HAS its own ideals of beauty; that of the 1850s stressed ample proportions in the female form. The rather striking foreshortening of this image does not allow us easily to judge the model's conformity to the canon. Her earrings, necklace, bracelet and rings have been pierced through to the silver of the plate and thus sparkle under strong light.

Anonymous
French
Reclining nude with veil
c. 1855
Inside frame 5·6 × 6·5 cm (half of a stereograph)

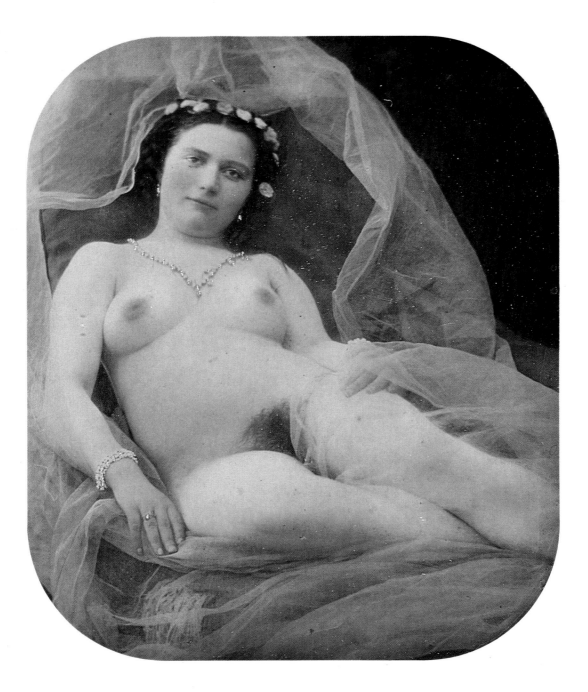

IN THIS PLAYFUL and amusing scene two women struggle with a corset. The photograph may be by F. Jacques Moulin, who is said to have used his wife and daughter in erotic pictures, but the attribution cannot be confirmed. The younger of the two models appears in more domestic guise in the plates on pp. 102–3.

Moulin was born in Paris, and he 'began his career by lending himself to indecency', as a biography curtly puts it. From 1850 Moulin took 'daguerreotype portraits of pretty women . . . and studies from life for artists'. He was praised in the magazine *La Lumière* as a skilled and artistic photographer. In 1856–7 he travelled in Algeria and took a series of landscapes and portraits using the collodion process.

Anonymous
French
Two women undressing one another on a bed
c. 1855
Inside frame 5·4 × 6·5 cm (half of a stereograph)

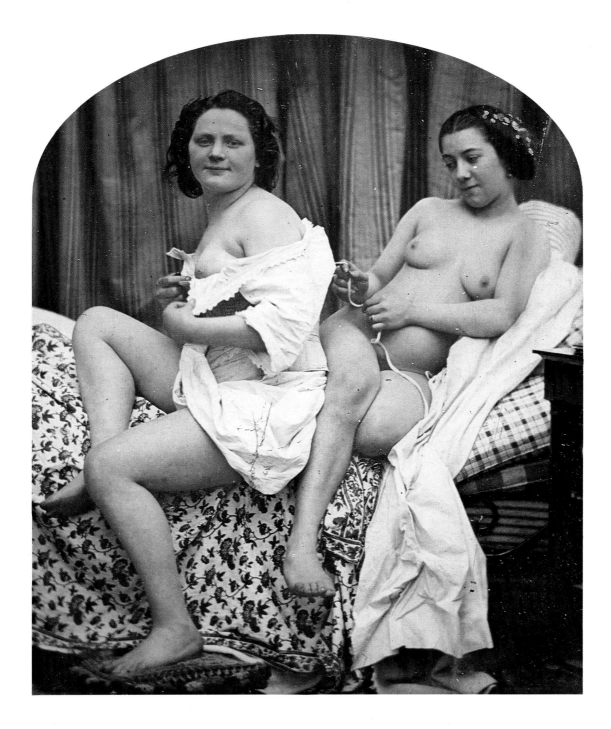

THE PARISIAN photographers of erotic stereographs tried to remain anonymous. Their documents of human pleasures added sensual excitement to the lives of wealthy European and American gentlemen amid all the Victorian prudishness of the 1850s. At this time Paris was the international centre of entertainment and the manufacturing centre of nude photography.

Anonymous
French
Nude woman with veil
c. 1855
Inside frame 5·6 × 6·5 cm (half of a stereograph)

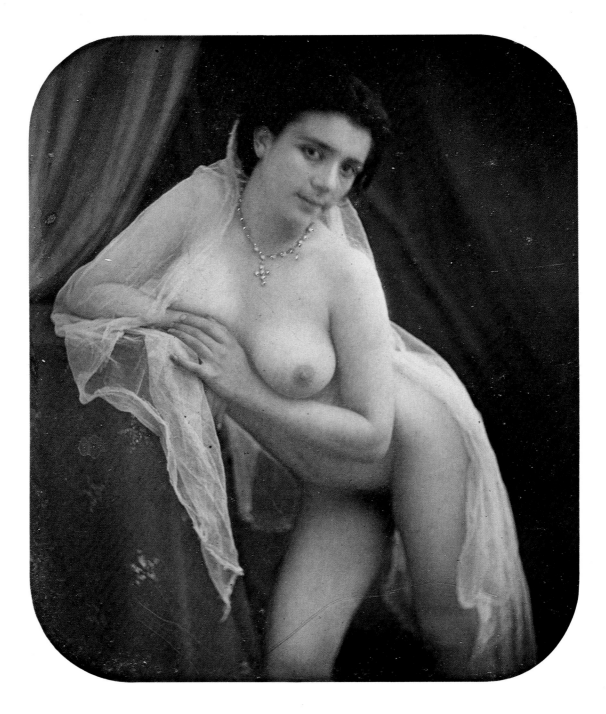

IN THESE 'SAUCY' photographs, the same woman poses as a cook in a 'kitchen' set up in the studio. She is armed in the first with a large cabbage, and in the second, with overt innuendo, she pours liquid into a bottle. It is curious to see which kitchen tools were considered emblematic, along with the inlaid oven and the water-container; a pair of bellows rests on the latter. The reflection of the studio skylights may be seen on the bottle.

The women who posed for erotic daguerreotypes were at first professional models, but later mainly working-class women, no doubt attracted by the relatively high pay: washerwomen, needlewomen, housemaids, messenger-girls and prostitutes. Their names are not known. In the daguerreotype, as in the brothel, class barriers were transcended.

Anonymous
French
Semi-nude woman in kitchen, holding bottle
c. 1855
Inside frame 5·6 × 6·7 cm (half of a stereograph)
Semi-nude woman in kitchen, holding cabbage
c. 1855
Inside frame 5·6 × 6·2 cm (half of a stereograph)

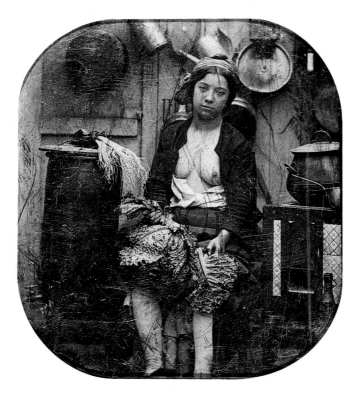

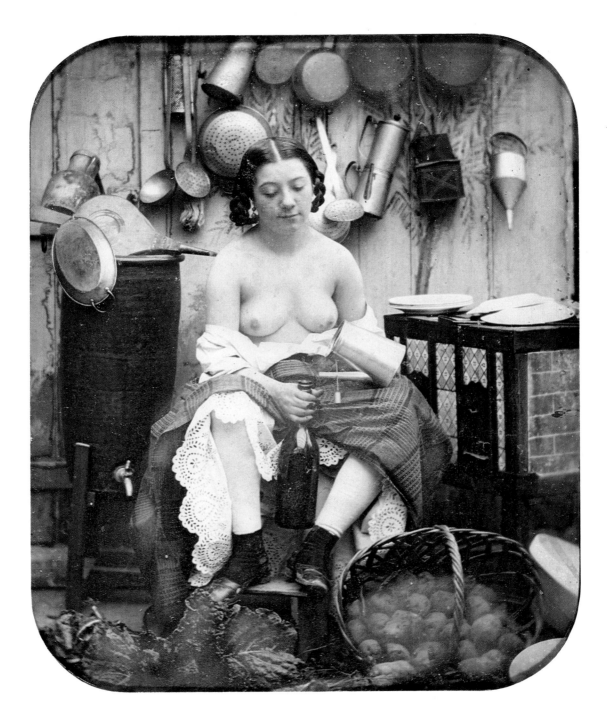

THE TOLERANCE SHOWN towards pornographic daguerreotypes in Paris was by no means official. The prohibition of the sale (not possession) of pornographic daguerreotypes was not extended to similar paintings or other media, and distributors discreetly carried on their activities in the hope that the police would or could be persuaded to overlook them. Daguerreotype nudes could be bought but not displayed in opticians; the main outlets for more explicit pictures in both Paris and London were the luxury brothels.

Certain Parisian studios accepted commissions to make nude photos to a customer's requirements, and the frumpish Nordic goddess may belong to this category. The two pornographic scenes show a concern for explicitness that is amusingly at odds with realism; the length of exposure required enhances the element of artifice in the 'orgy' scene.

Anonymous
French
Bare-breasted woman in armour
c. 1855
Plate 6 × 7·4 cm (detached half of a stereograph)

Anonymous
French or Austrian
Pornographic scene
c. 1855
Plate 6·3 × 7·1 cm (detached half of a stereograph)
Group pornographic scene
c. 1855
Plate 6·4 × 7·4 cm (probably half of a stereograph)

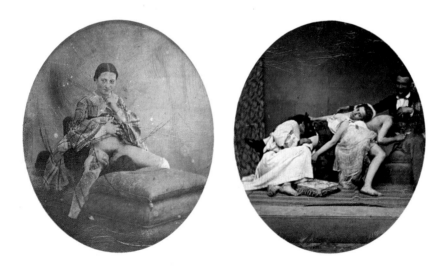

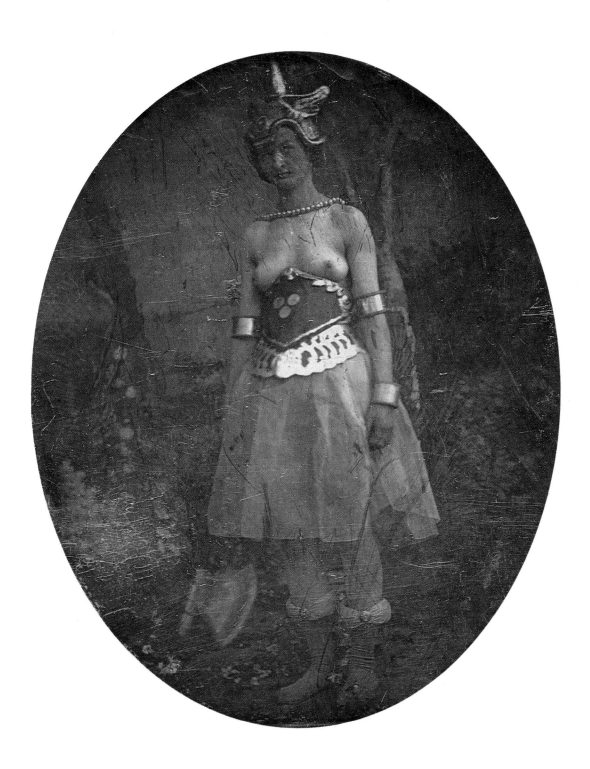

NUDITY HAS LOST much of its power to threaten since this daguerreotype was taken, while the accessories have gained with age a certain quaint charm of their own. As the studios that specialized in nudes were often used by more than one photographer, portraits and nudes are sometimes found to contain exactly the same background furniture or fabrics.

Anonymous
French
Nude with armchair
c. 1855
Inside frame 5·9 × 6·8 cm (half of a stereograph)

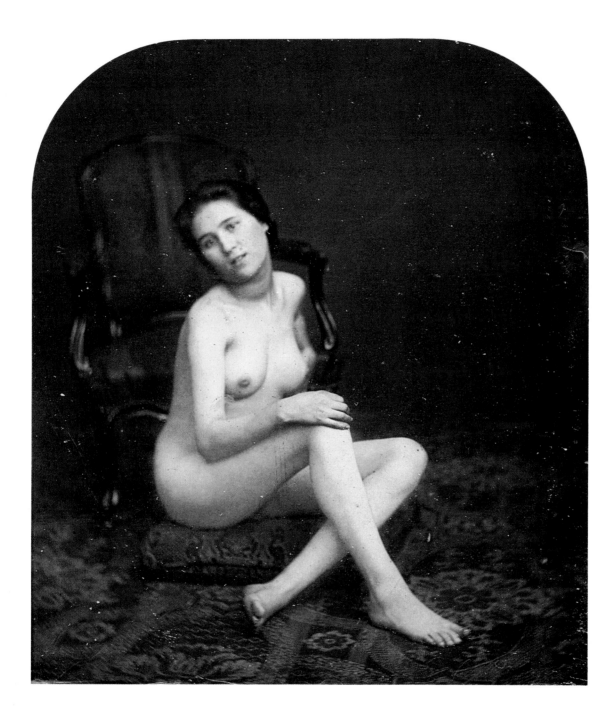

THIS CHARMINGLY suggestive scene shows two young women embracing each other. The viewer may be expected to account for their state of trepidation by the coincidence of his or her presence and the girls' rather transparent garb.

Anonymous
French or Austrian
Two girls embracing one another
c. 1855
Plate 6·6 × 7·3 cm (probably half of a stereograph)

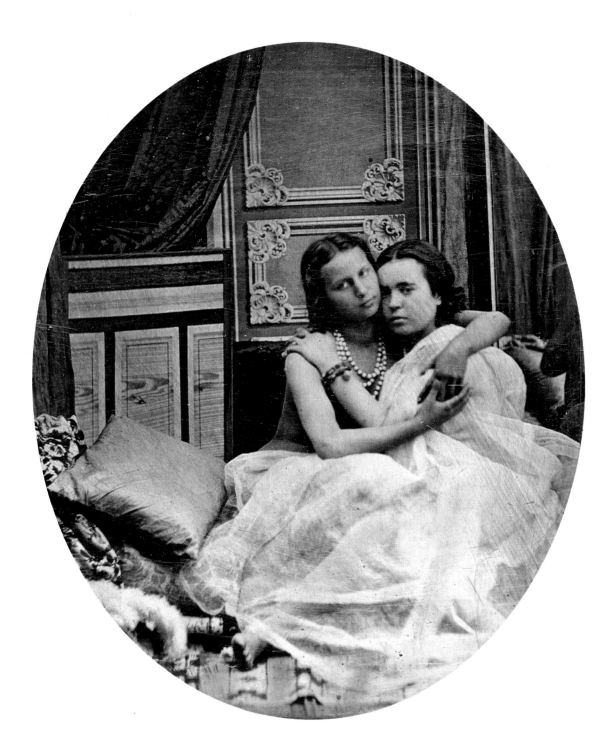

PHOTOGRAPHS ADMIRABLY convey the volume of buildings and monuments, and with its high definition the daguerreotype was well suited to capturing architectural detail. The English art critic John Ruskin used daguerreotypes for his drawings of architecture, and prized them for their speed and accuracy: 'It is very nearly the same thing as carrying off the palace itself,' he wrote from Venice in 1845.

The photographer Flécheux, whose studio was at 31 Boulevard du Temple, took this and the following view in or around 1850. The Dôme des Invalides was built from about 1679 to 1691 by order of Louis XIV. It is a masterpiece of the baroque, and since 1840 has contained the tomb of Napoleon I.

Flécheux (active *c.* 1842–55)
French
Église du Dôme des Invalides, Paris
c. 1850
Plate 8·1 × 10·4 cm (quarter plate)

THE PLACE DE la Concorde was designed as an octagon in 1755. At its centre is the 23-metre, 220-ton Obelisk of Luxor, a granite monolith from a temple in Luxor, where it had stood for more than three thousand years. The long exposure has transformed the water of the two fountains that flank the obelisk into a ghostly plume.

Flécheux (active *c.* 1842–55)
French
Place de la Concorde, Paris
c. 1850
Plate 8·1 × 10·3 cm (quarter plate)

THE STREETS OF THIS French town were not necessarily empty, but the passers-by were not recorded by the daguerreotype and left not so much as a blurred trail of their presence. The effect is slightly eerie:

And, little town, thy streets for evermore
 Will silent be; and not a soul to tell
 Why thou art desolate, can e'er return.

The high definition of the daguerreotype is a source of endless fascination. In the original one can see the display in the window of the Coiffeur Guerreau with the aid of a magnifying glass. The writing in the signs on the plate is not reversed, which means that the photograph was taken using a mirror.

Anonymous
French
View of a French town
c. 1842
Plate 8·1 × 9·9 cm (quarter plate)

LANDSCAPES URBAN and pastoral are among the most sought-after daguerreotypes, and this is an exceptionally fine example. The identity of the artist is not known, but the fact that the image was obtained from the same source and uses the same framing material as the two views of Paris by Flécheux (see plates facing pp. 110 and 112) offers grounds for a speculative attribution to that artist. The view is of Amsterdam and is one of a series; 'No. 4' is inscribed on the plate.

The photographer was clearly a most accomplished artist, as the immaculate composition testifies. Two dockers are at work loading or unloading a consignment of heavy sacks on a quay not far from the site of Rembrandt's house. They have put their work down (the photographer probably asked them to remain still for the duration of the exposure) and are looking towards the camera, which was set up on its tripod on the bridge that joins the Jodenbreestraat and the St Antoniesbreestraat. The three houses behind the boats no longer exist. The drawbridge too has disappeared, and in its place today is a modern fixed construction. The Montelbaanstoren, a sixteenth-century fortified tower on the Old Entrenchment (Oude Schans) may be seen in the far distance. It is sometimes possible, as in this case, to trace the exact spot from which a daguerreotype was taken, despite the changes wrought by the long intervening years. The bare branches of the trees tell us that the season is late autumn or winter. A street-lamp is visible at the extreme left, and a dog is wandering along the canal.

Attributed to Flécheux (active
c. 1842–55)
French
View of Amsterdam
1850
Plate 11·3 × 8 cm (quarter plate);
illustrated reversed

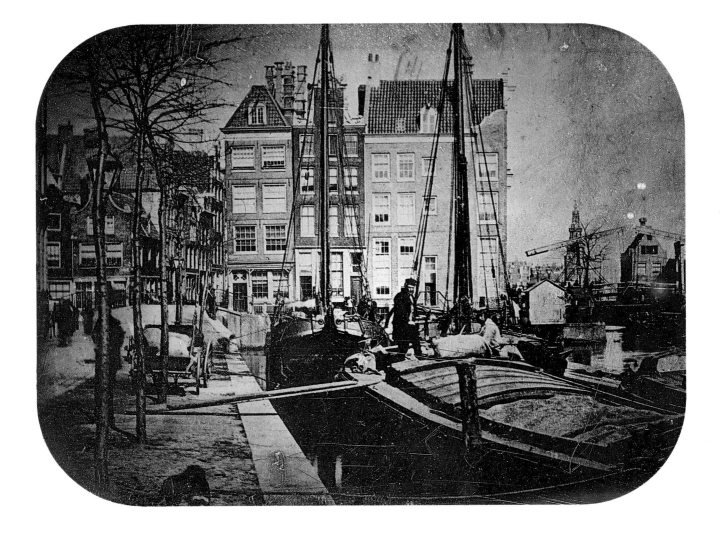

THIS EXTREMELY detailed view of Lyons and the Rhône shows the 1855 reconstruction of three of the five pillars of the Saint-Clair Bridge. The first Saint-Clair Bridge was built in 1844 to connect Lyons, whose centre is on a peninsula dividing the rivers Rhône and Saône, with the left bank of the former. The bridge's style led it to be referred to as the 'Egyptian Bridge'. On 29 June 1854 exceptionally high waters tore a mill-boat from its moorings – the seven others are still to be seen in the image – and the impact of the boat on the middle pillar of the bridge caused its collapse. No one was hurt; a miller on the boat escaped, and the pedestrians on the bridge were able to run to safety. It was then decided to build a new suspension bridge, as may be seen.

On the left-hand side of the photograph lies the right bank of the Rhône and the first Lyons pump-house, with smoke blowing northwards from its chimney. Built in 1853, it pumped water up the ninety metres to the reservoirs of the Croix-Rousse Plateau. Below the pump-house is a laundry boat. Half-way up the hill on the left of the image are the entrenchments that once separated Lyons from the Croix-Rousse district, which was then independent of Lyons. On the right it is possible to make out the tip of the Parc de la Tête d'Or, which opened one year after the photograph was taken, at the same time as the rebuilt bridge. All this detail is visible despite the small size of the daguerreotype, which is only a quarter plate.

Anonymous
French
View of Lyons
1855
Plate 10·6 × 8 cm (quarter plate)

118

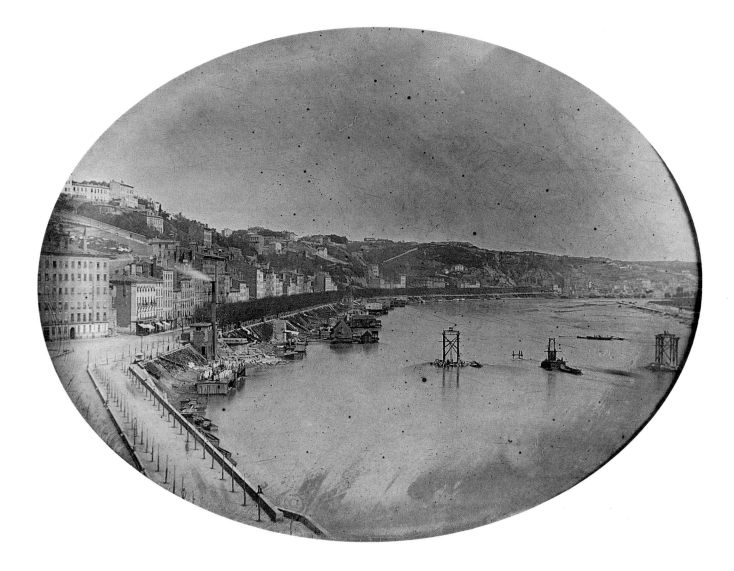

BRÉVIÈRE LIVED IN Rouen. He revived the art of the woodcut in France and was also an excellent lithographer. From 1829 he was involved with the *Imprimerie royale*, the Royal Press, in Paris, of which he was named the official draughtsman and engraver in 1834. He discovered the principle of photogravure in 1832, and in 1843 made experiments with a view to creating engraving plates from daguerreotypes.

These two etched daguerreotypes are samples of Brévière's early experiments, and as such are extremely rare. The view is probably taken from his window. A similar image appears as a photogravure in Adeline's biography of Brévière, *Notes on the Life and Works of a Norman Artist* (1876), in which Adeline records that Brévière took no more than two prints of each of the three subjects he engraved from daguerreotype. Daguerreotype etchings were made with nitric acid, which attacked only the bare silver (the shadows of the image) and could not dissolve the mercury amalgam. The result was a very superficial etching, and only a hundred or so prints could be created. Fizeau's method for stabilizing the amalgam with gold allowed deeper etchings to be made, from which several hundred prints could be produced. But before any satisfactory technique for photomechanical illustration was evolved, the collodion process with its negative–positive capacities came into use.

Louis-Henri Brévière (1797–1869)
French
View out of a window
Etched daguerreotypes
Left plate: 28 August 1843;
5·6 × 8·1 cm (eighth plate)
Right plate: 22 July 1843;
5·2 × 8·2 cm (eighth plate)

ON 1 MAY 1851 the Great Exhibition opened in the extraordinary glass and iron-framed halls of the Crystal Palace in Hyde Park, London. It contained an arrogant and euphoric expression of the power of the industrializing nations; the latest achievements of industry and art were presented by 13,000 exhibitors to more than six million visitors. In the central 'nave' of this temple to progress – it was three times the length of St Paul's Cathedral – one could admire a giant telescope, a lighthouse reflector and the Koh-i-noor diamond.

The outcry when the time came to pull down this immense construction was such that it was decided to rebuild it elsewhere; the site chosen was in Sydenham in south London. The noted painter–photographer Philip Henry Delamotte was commissioned to document the rebirth of the palace, and he eventually published two volumes of photographs taken by the collodion process. Queen Victoria and Prince Albert attended the opening ceremony in 1854, and the building was blessed by the Archbishop of Canterbury. (It burnt down nevertheless in 1936.) Among the new attractions were life-size replicas of the colossi of Abu Simbel as well as statues for which fig-leaves were urgently sought before the royal visit.

This interior view was probably taken by Thomas Richard Williams, who worked for a time in the studio of Delamotte. It is incredibly detailed; the structure of Sir Joseph Paxton's palace (300,000 sheets of glass in an iron web) and Osler's 'Crystal Fountain', with its many tons of elaborately worked crystal, are exceedingly clear. The frame of the stereograph bears the label of the optician Amadio; souvenir daguerreotypes of this kind were retailed through opticians. The term 'souvenir' should not obscure the fact that every daguerreotype was unique.

Attributed to Thomas Richard Williams (1825–71)
British
Interior of the Crystal Palace at Sydenham
c. 1854
Inside frame 5·7 × 6·6 cm (half of a stereograph)

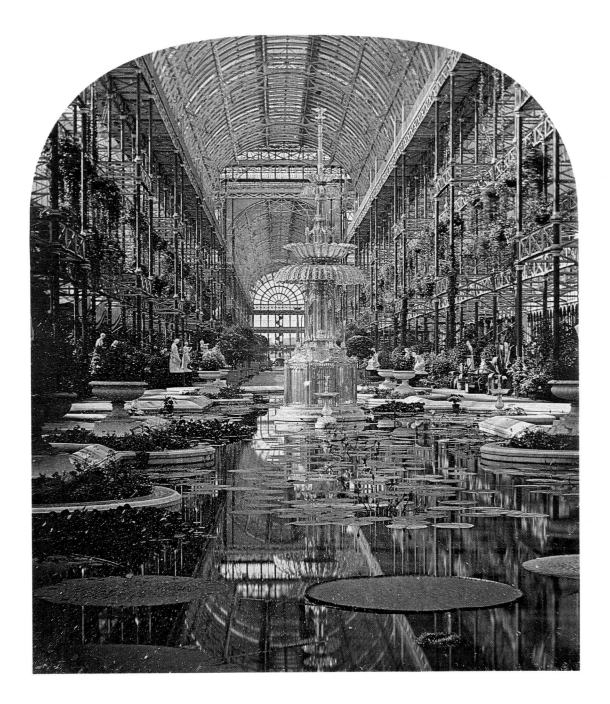

THE GERMAN Schneider brothers took this rather prosaic view of the Kremlin during their visit to Moscow in 1861. On the left is the huge Water Tower, and at its foot the wall enclosing the Kremlin. Behind it looms the formidable mass of the Kremlin Great Palace with its 700 rooms, among them the private chambers of the tsar. To the right are the Cathedral of the Annunciation and the Cathedral of the Archangel, traditionally the last resting-place of the tsars. The tall Belfry of Ivan the Great stands behind, and the River Moskva flows in the foreground.

THIS EXCEPTIONAL daguerreotype view of a shipbuilding yard shows six men working on a pile of wooden beams and raw timber, watched by the master shipwright. The boat's hull has already been completed and the building of its superstructure has begun. A high fence separates the shipyard from the sea, on which four sailing ships may be seen.

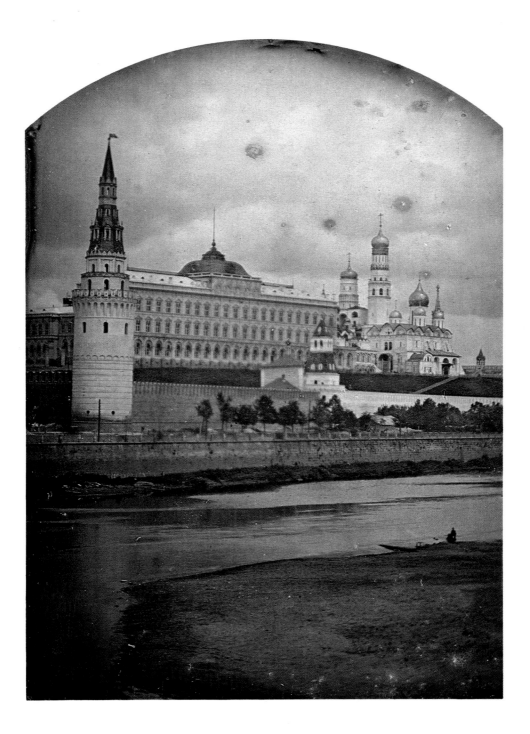

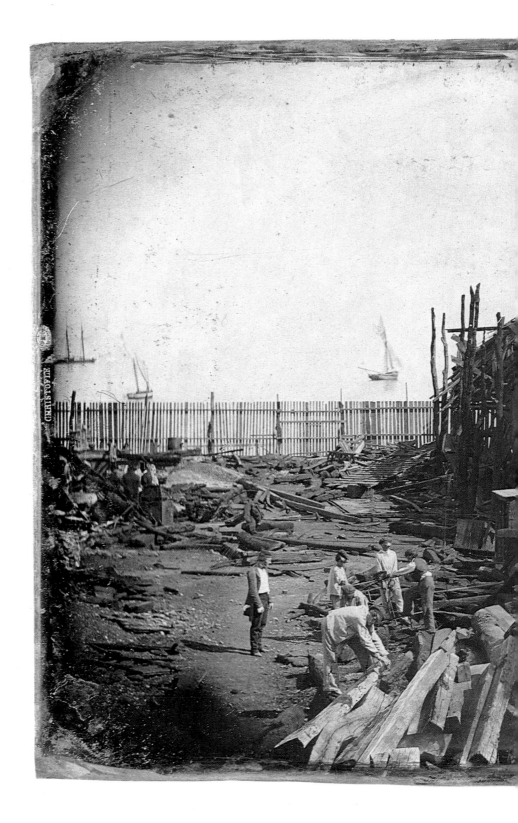

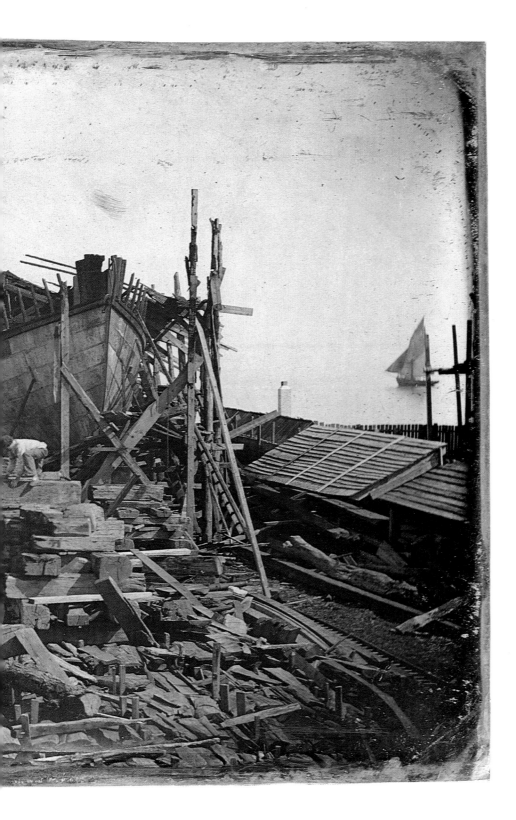

SAMUEL MORSE remarked in 1840, 'Daguerreotypes cannot be called copies of nature, but portions of nature herself.' In this impressive view of the Horseshoe Falls the American reverence for nature finds its perfect expression. The long exposure has given the water a wonderful, unearthly texture, at once blurred and milky. Indeed, the virtue of the picture lies precisely in its failure to record nature as we see it: it shows the falls as the imagination rather than the eye sees them. In modern photographs Niagara Falls often look banal, for the short exposure 'stills' the water and the impression of surging movement is lost. The scene was a favourite one for daguerreotypists: H. L. Pattinson's 1841 view was reproduced in Lerebours's '*Excursions daguerriennes*', and the German Langenheim brothers gained considerable publicity in 1845 by presenting copies of their five-plate panorama of the falls to the principal sovereigns of Europe.

Babbitt held a monopoly of daguerreotyping the American side of the falls; he set up his camera on a permanent tripod in a pavilion that served as his outdoor studio and photographed the tourists viewing the Horseshoe Falls from Prospect Point. Charles Dickens, who visited the spot in 1842, complained about the pollution, but Babbitt's picture records an untouched wilderness. The tourists were captured unawares in their confrontation with the sublime. Babbitt was probably the first such souvenir photographer, and he staunchly defended his monopoly. A Mr Thompson from Scotland was unable to take a single picture, as every time he removed the lens cap Babbitt leapt in front of the lens with a large umbrella.

In 1854 a canoe overturned above the falls, and one of the canoeists hung on to a branch wedged between some rocks for eighteen hours before, all rescue attempts having failed, he too was swept to his death. The several shots that Babbitt took of the doomed man are early examples of another genre, the 'newsworthy' photograph.

Platt D. Babbitt (active at Niagara Falls 1854–65)
American
Tourists viewing Niagara Falls from Prospect Point
c. 1855
Plate 13·9 × 10·7 cm (half plate)

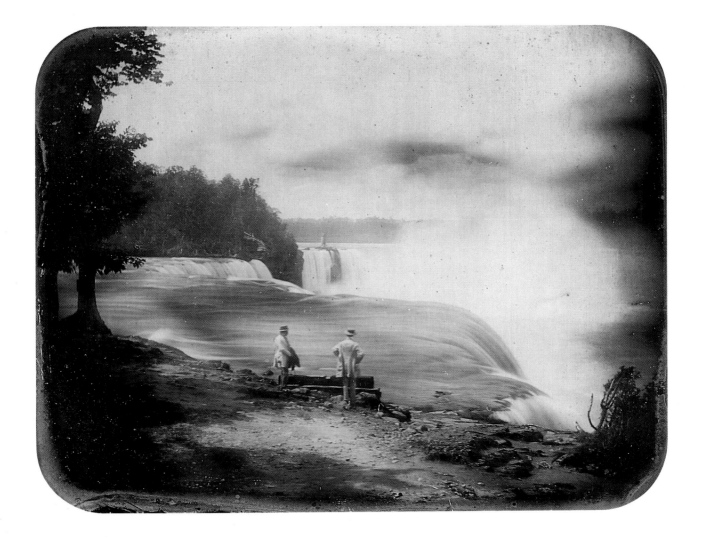

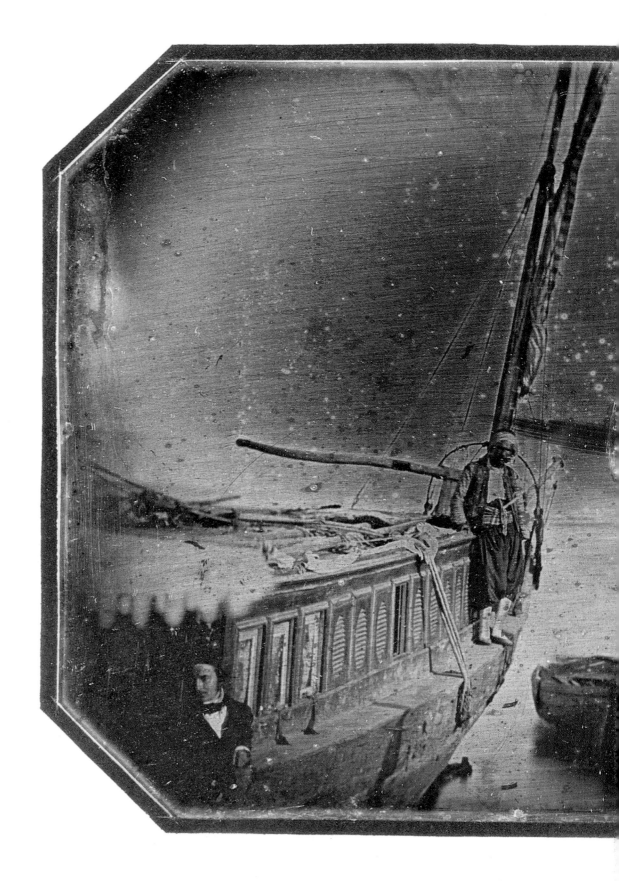

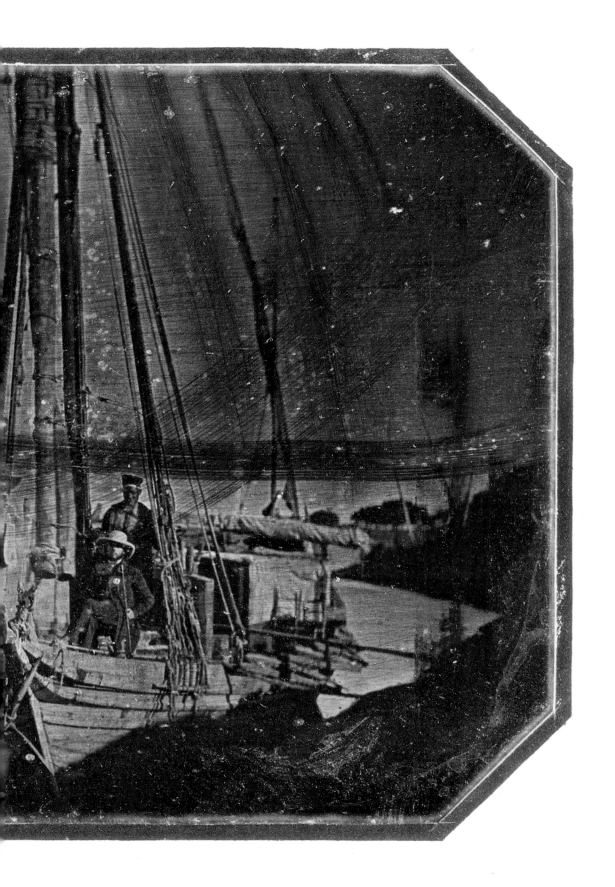

THE FRENCH CIVIL SERVANT Jules Itier travelled to China in 1843 as the head of a commercial mission to finalize an agreement with the Chinese. He was a keen amateur photographer and the first person to take photographs in Singapore, Macao and the province of Canton. On his return journey Itier visited the Philippines, Java and Borneo, and in December 1845 and January 1846 he toured Egypt, where he took this photograph of his companions on their boats on the Nile. On the right-hand boat is M. de Montherot (*seated*) who had come from France to bestow upon Mohammed Ali the *Grand cordon* of the *Légion d'honneur*. To his right, leaning against the boat's rigging, is Mr D'Aguilar, a captain of the Guards of Queen Victoria. The expedition voyaged the 450 miles up the Nile to the First Cataract and the temples of Philae near Aswan. Itier chose to return from there to Alexandria by crossing the Libyan Desert. He himself is probably to be seen by the boat in the left-hand corner of the photograph, having asked an assistant to take off the lens cap and make the exposure. It is a very rare and important document of this early photographic expedition.

The view of Cairo was taken from the Citadel, a fortress constructed by Saladin in 1176 on a spur of the Muqattam Hills. The fortress stands on the south-eastern edge of the city, overlooking what is now called Islamic Cairo, the walled city in which the flower of the medieval Islamic architecture of Cairo is concentrated. The numerous mosques of the sector can be studied in detail with the aid of a magnifying glass, owing to the extraordinarily sharp detail of the daguerreotype process; the collodion method that superseded the daguerreotype is incapable of this degree of definition.

Jules Itier (1802–77)
French
Preceding plate: *The expedition members on their boats on the Nile*
1845
Inside frame 14·4 × 9·3 cm (half plate)
Opposite and overleaf: *View of Cairo from the Citadel*
1845
Inside frame 15·1 × 10·9 cm (half plate)

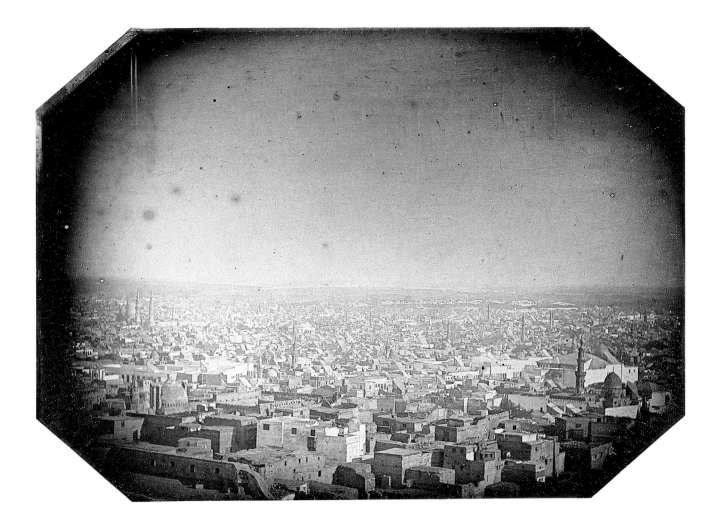

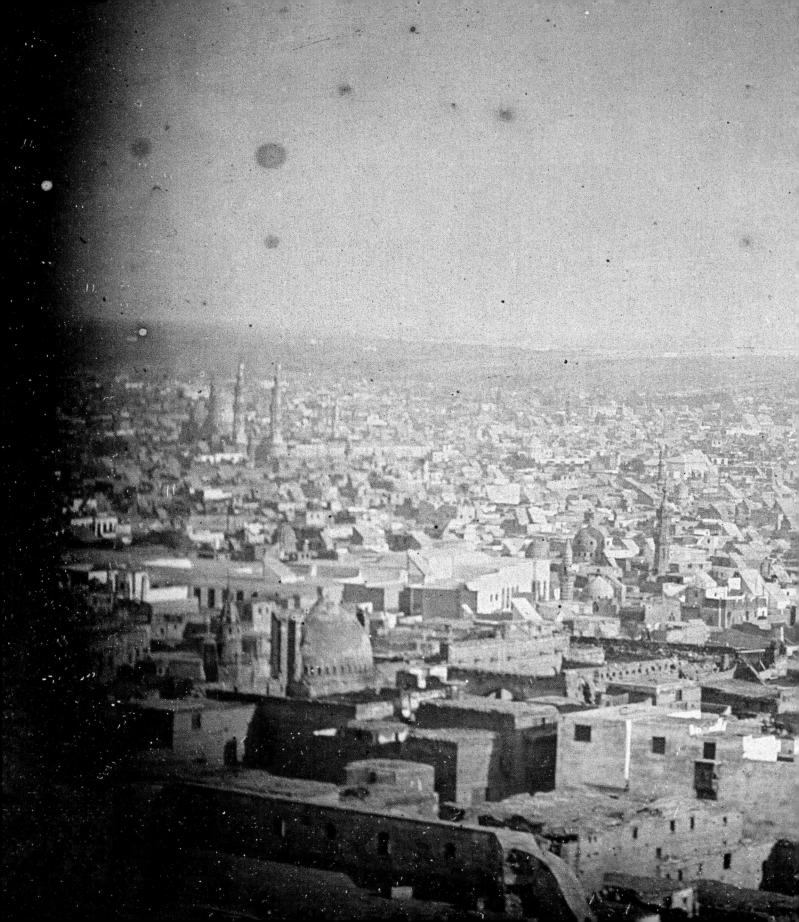

Select Bibliography

Books

BERNARD, B., *Photodiscovery*, London, Thames and Hudson, and New York, Abrams, 1980.

BULL, D., and LORIMER, D., *Up the Nile, a Photographic Excursion: Egypt 1839–1898*, New York, Clarkson N. Potter, 1979.

DAGUERRE, L. J. M., *Histoire et description du procédé nommé le Daguerréotype*, Paris, Giroux, 1839; reproduced in facsimile with English translation in *A Historical and Descriptive Account of the Various Processes of the Daguerreotype and the Diorama*, New York, Winter House, reprinted 1971 with introduction by B. Newhall.

EDER, J. M., *History of Photography*, New York, Dover, 1978.

FABIAN, R., and ADAM, H. C., *Masters of Early Travel Photography*, New York, Vendome Press, 1983.

FREYERMUTH, G. S., and FABIAN, R., *Der erotische Augenblick*, Hamburg, Gruner und Jahr, 1984.

GERNSHEIM, H., *L. J. M. Daguerre: The History of the Diorama and the Daguerreotype*, New York, Dover, 1968.

—, *The History of Photography*, London, Thames and Hudson, and New York, McGraw-Hill, 1969.

—, *The Origins of Photography*, London, Thames and Hudson, 1982.

GILBERT, G., *Photography: The Early Years*, New York, Harper and Row, 1980.

HAWORTH-BOOTH, M., *The Golden Age of British Photography 1839–1900*, New York, Aperture, 1984.

KEMPE, F., *Daguerreotypie in Deutschland*, Seebruck, Heering, 1979.

LEMAGNY, J. C., and ROUILLÉ, A., *A History of Photography*, Cambridge, Cambridge University Press, 1987.

MACDONALD, G., *Camera: A Victorian Eyewitness*, London, Batsford, 1979.

NEWHALL, B., *Latent Image: The Discovery of Photography*, New York, Doubleday, 1967.

—, *The Daguerreotype in America*, New York, Dover, 1976.

—, *The History of Photography: From 1839 to the Present*, New York, Museum of Modern Art, 1982.

PFISTER, H. F., *Facing the Light: Historic American Portrait Daguerreotypes*, Washington, Smithsonian Institution, 1978.

RINHART, F., *American Daguerrian Art*, New York, Clarkson N. Potter, 1967.

RINHART, F., and RINHART, M., *The American Daguerreotype*, Athens, G A, University of Georgia Press, 1981.

ROSENBLUM, N., *A World History of Photography*, New York, Abbeville, 1984.

RUDISILL, R., *Mirror Image: The Influence of the Daguerreotype on American Society*, Albuquerque, University of New Mexico Press, 1971.

SOBIESZEK, R. A., *Masterpieces of Photography*, New York, Abbeville, 1985.

SOBIESZEK, R. A., and APPEL, O. M., *The Spirit of Fact*, Boston, David Godine, 1976.

—, *The Daguerreotypes of Southworth and Hawes*, New York, Dover, 1980.

STAPP, W., *Robert Cornelius: Portraits from the Dawn of Photography*, Washington, Smithsonian Institution, 1983.

TAFT, R., *Photography and the American Scene: A Social History*, New York, Dover, 1964.

THOMAS, D. B., *'From Today Painting is Dead': The Beginnings of Photography*, London, Arts Council of Great Britain, 1972.

WELLING, W., *Photography in America: The Formative Years 1839–1900*, New York, Thomas Y. Crowell, 1978.

WITKIN, L. D., and LONDON, B., *The Photograph Collector's Guide*, Boston, New York Graphic Society, 1979.

Catalogues

Daguerre 1787–1851 et les premiers daguerréotypes français, Paris, Bibliothèque Nationale, 1961.

De Niépce à Man Ray, Paris, Musée des Arts Décoratifs, 1965.

Regards sur la photographie en France au XIXᵉ siècle: 180 chefs-d'œuvre de la Bibliothèque Nationale, Paris, Berger-Levrault, 1980.

After Daguerre: Masterworks of French Photography (1848–1900) from the Bibliothèque Nationale, New York, Metropolitan Museum of Art, 1980.

Index

138